U0115116

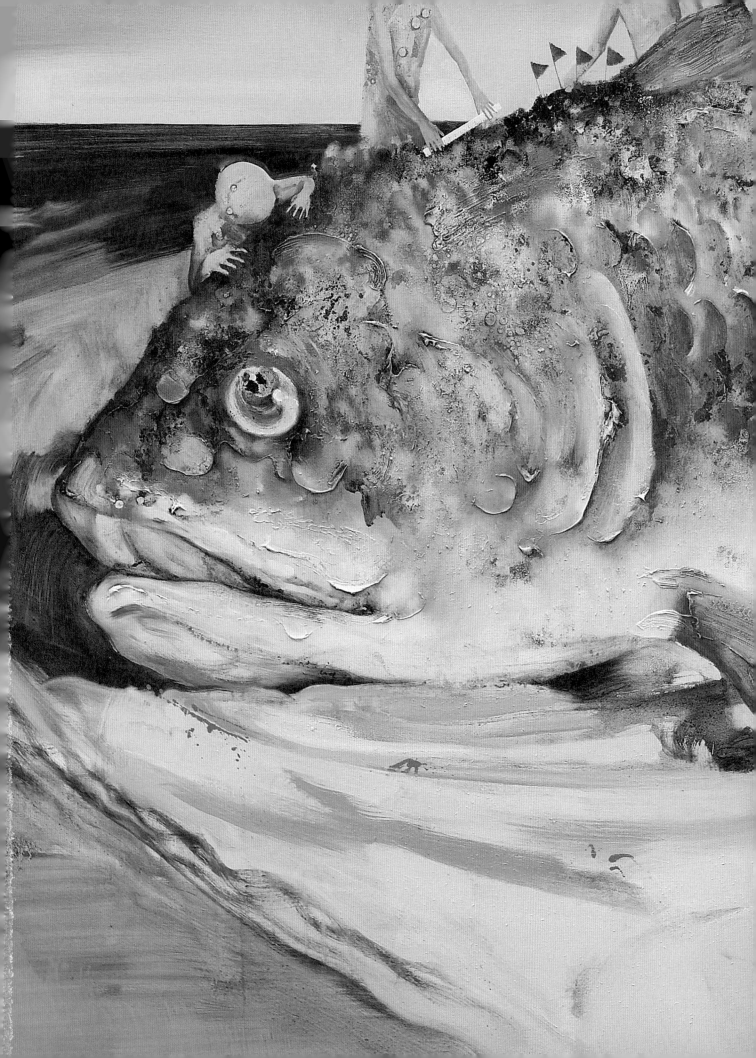

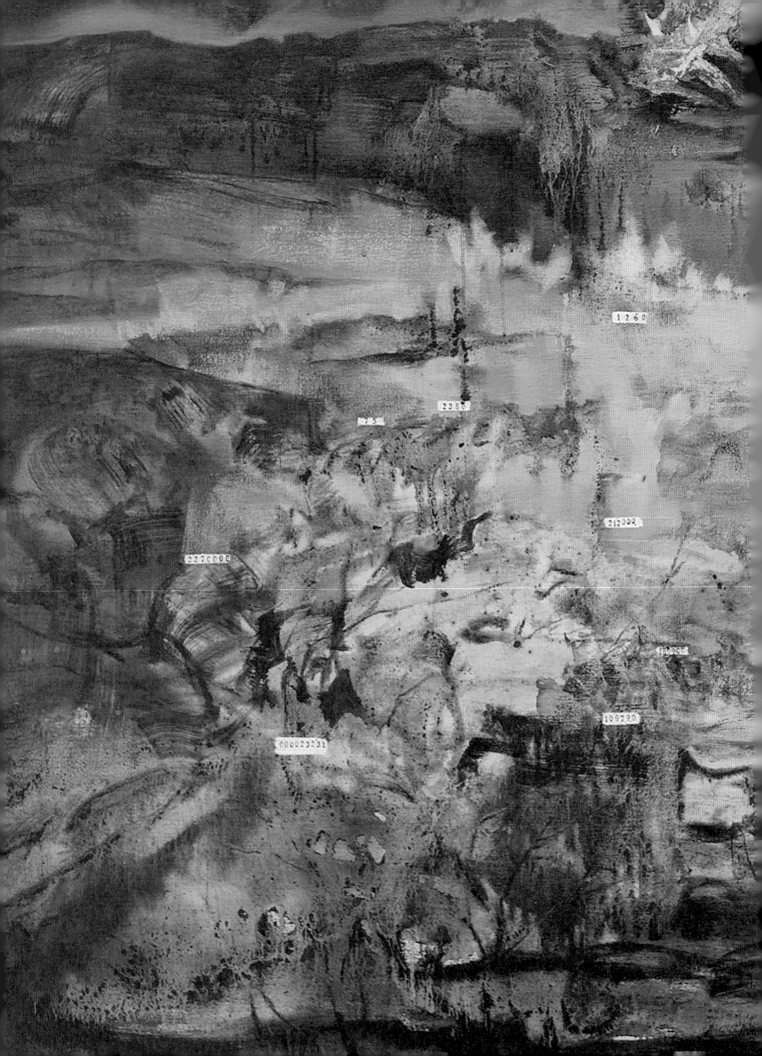

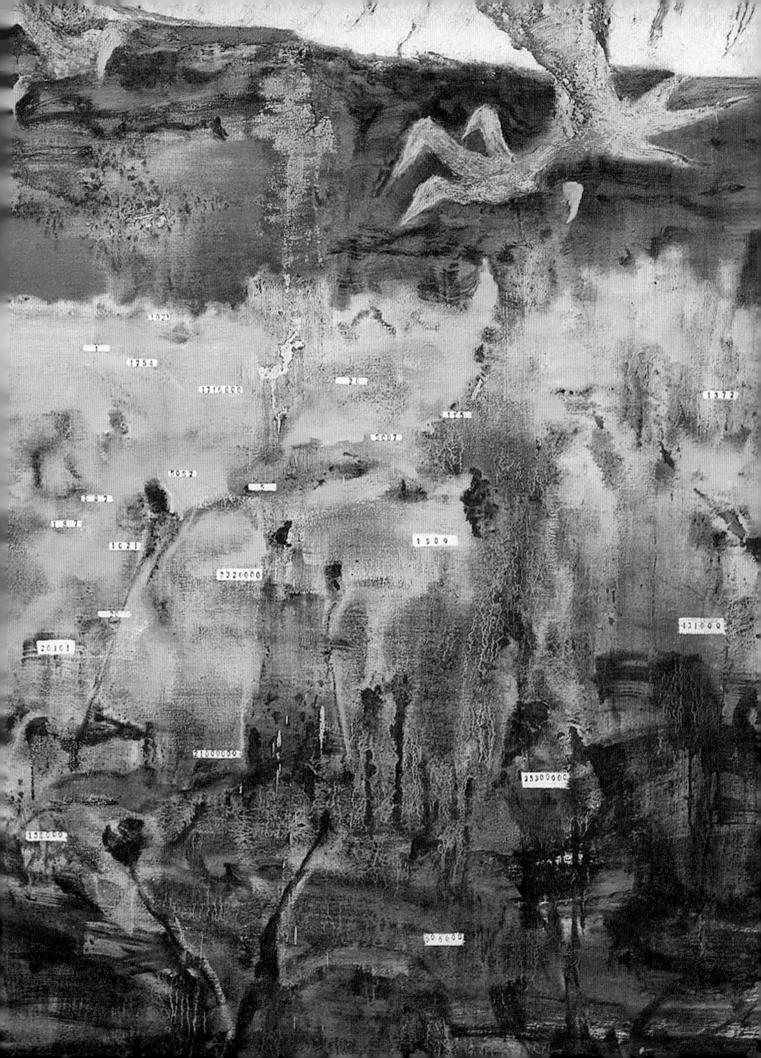

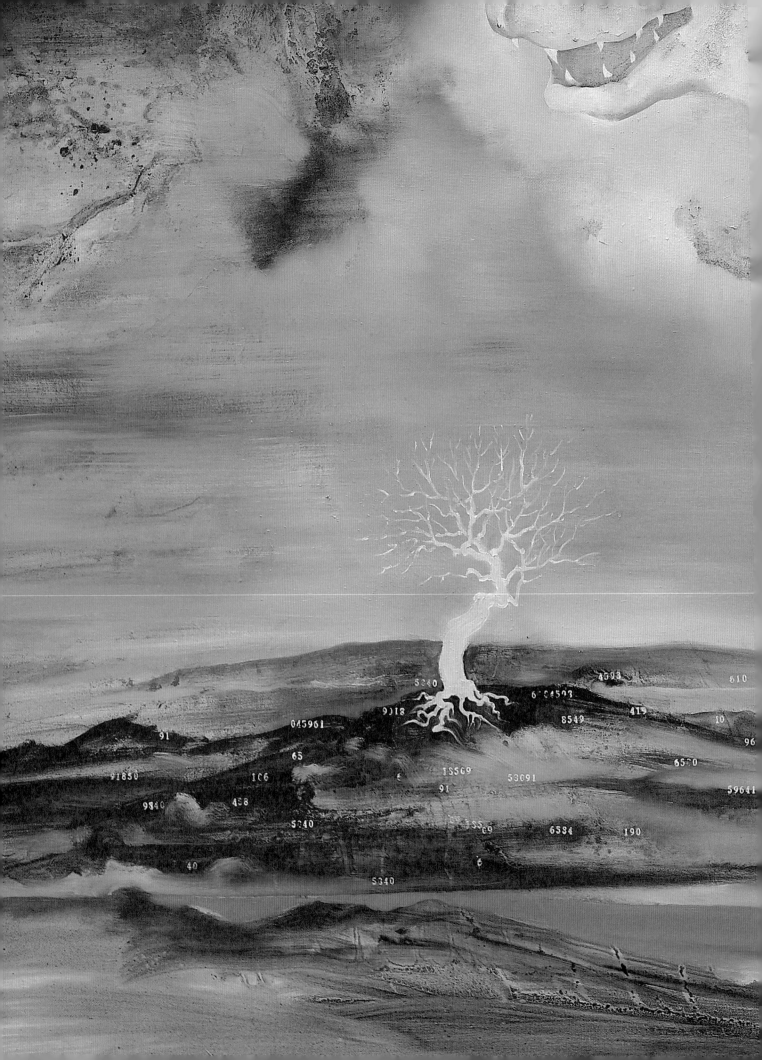

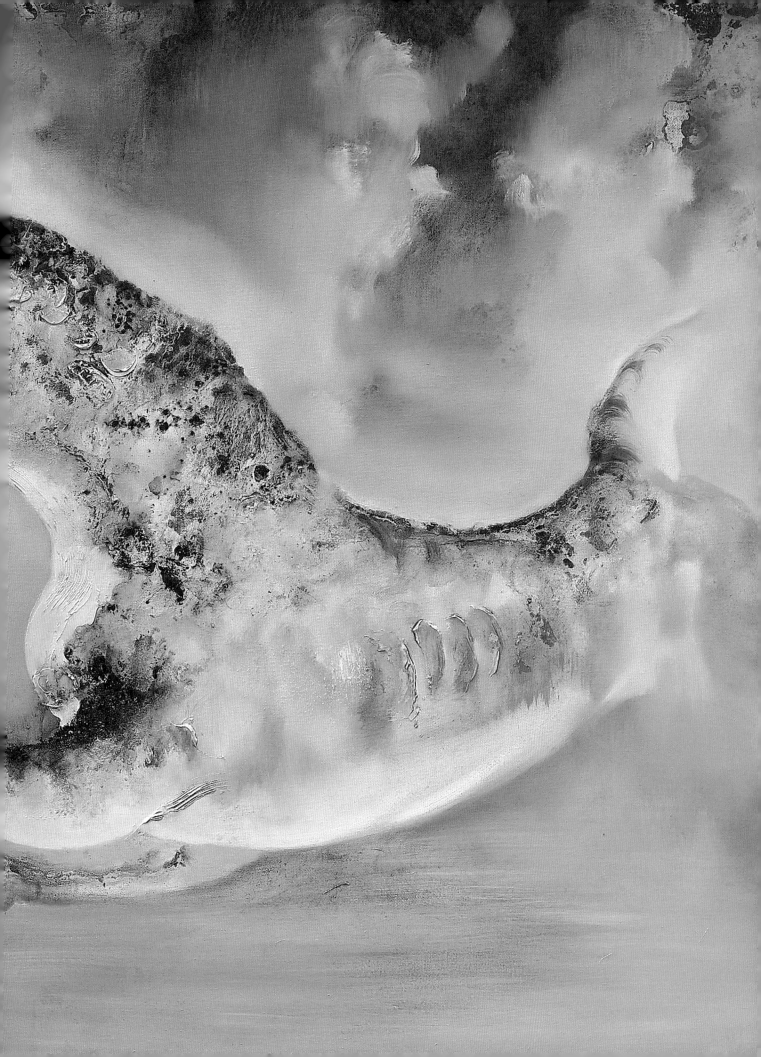

异述 alternative reference

魏言　Wei Yan

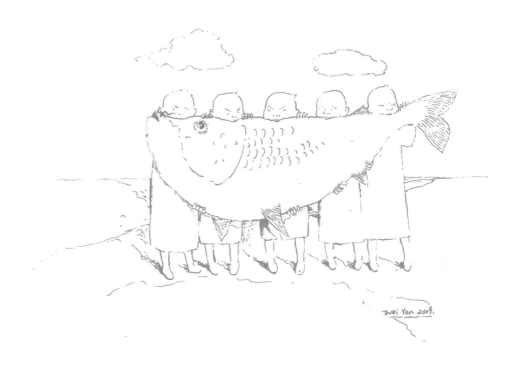

四川出版集团
四川美术出版社

Detail 01

梦溪笔谈(局部)，布面油画，160×200厘米，2009年
The Dream Rivulet Didry(detail), Oil on canvas, 160×200cm, 2009

Detail 02

与大龙有关的33组数据(局部)，布面油画，200×250厘米，2005-2009年完成
33 sets of data related to big dragon(detail), Oil on canvas, 200×250cm, finished in 2005-2009

Detail 03

冥想3：欲望眼睛(局部)，布面油画，160×200厘米，2008年
Memory No.3- Eyes of Desire(detail), 160×200cm, 2008

Published in October 2009

Contents

自序

魏言

妙善异述，达者共传……

欧阳询《书论》

……南中有枫子鬼木之老者，为人形，亦呼为灵枫，盖瘿瘤也。至今越巫有得者，以之雕刻鬼神，可致灵异。

《述异记》

异述，民间杂谈式的讲述。当代艺术不应该仅仅满足于世界经济体系下的美术馆、艺术评论、画廊、经纪人、艺术基金会等专业话语系统，它更应该具备一种民间杂谈的乡野性；具备一种体制外的特征；具备一种鬼使神差的生机。所以，我所追求的艺术正是以艺术家特殊的心智映照出来的现实经验。我不喜欢直白地去表现当代主题，而更喜欢选择一种在当代现实经验中的"异述"。异述，包含着"不同的参照"的含义，面对共同感受的历史和生存现实，我选择了另一种讲述方式，以另一种知识参照来考察人们今天的生活应该会更有意思和乐趣，也应该获得更重要的艺术价值。让我们绕过当代讲述中诸如"消费""物欲""权力"等等平庸的社会学注解，找寻异样的生命感受，以另一种在"远古"等待着我们的心智去感受现实。当这个时代的危机来临，我们方可以解脱内心那平凡的生存负荷，恢复一种神性的启示性思维，用神秘的感知与独白来找寻自己的存在。

2009年1月14日
写于北村独立工场

Foreword

Wei Yan

Nice and alternative references, achievers pass on
— Book Theory by Ouyang Xun

… Nan Zhong has an aged maple tree with human shape. People call it spirited maple, but actually it is Ying-Liu(cecidium). Local shamans use the wood to carve the statues of Gods or ghosts when they obtain it, believing such statues have special powers.
— Shu-Yi-Ji (Strange Stories)

Alternative reference is like folk talk. The contemporary art shouldn't be satisfied with the museum, gallery, dealer, business corporation and the alleged professional academic system under the world economic system. It should have a countryside character of folk by-talk, a character outside of system, a vitality of unexpected happenings. Therefore, what I pursue is the experience of reality that reflected by artist's particular mind. I don't like directly express the modern themes. I like the "alternative reference" in the contemporary experience of reality--- the concepts that the modern people have felt strange and numb, such as "psychic", "mysterious", "myth", "wild" and so on. "Alternative reference" includes the significance of "different reference". In the face of the common history and reality, I choose another way to tell. Using another kind of knowledge reference to study today's life will be more interesting and funnier. It should gain more important art value. Let us bypass the mediocre comments of sociology like "consume", "material desire", "power" to look for a strange feeling of life; another kind of "ancient" is waiting for us to experience the reality by our minds. When the crisis of the era comes, then we can relief the ordinary burden of existence in our hearts and restore a divine thinking of enlightenment, looking for the existence of the self by mysterious perception and monologue.

Jan. 14, 2009
North Village Independent Workshop, Chengdu

魏言艺术中的历史美学

黄专

在青年画家魏言以"灵兽"为题材的系列作品中，当代叙事被赋予了一种新的美学形式：各种当代问题在古代神话叙事框架中得到展开，各类超现实的视觉图像常常制造出一些特殊的诗性意向、一些人类学意义上的"乡愁"。

要理解这种新美学也许首先应该了解艺术家为自己预设的这样一个艺术问题：在本土神话学和人类学资源中寻找"灵性"的表达，这个设定为我们讨论他的艺术提供了一种关于历史的维度。还是让我们先从他自己的说法中来体会他的初衷：

……在被物质文化作用的今天，后现代的启蒙主义使得人类在一个功能性社会里正在大量散失了潜在的文化灵性，例如感受能力和想象能力，包括对知识的解释能力。人们的生活满足并追求着物质的功能性作用，而情感世界却因为这种机械而单调的生活方式而变得枯燥乏味。我试图通过艺术来表达这样不同的见解，意图唤醒或召回某些心智，由此恢复到一种自然敏感的状态，从而实现一个"人"的完整性。（《虫在昆仑——魏言艺术创作心路》）

后期海德格尔将对存在的形而上学的哲理之思转向对诗-思的追问：祛神的物质文化和技术时代使人陷入万劫不复的深渊，唯有"贫困时代的诗人"能够重新唤起人对自然生命和存在本质的记忆，摸索远逝诸神的踪迹，领会"天空"和"大地"之意，使人成为无蔽状态的"敞开者"，这几乎是人类拯救自己的一种别无选择的"冒险"《诗人何为》，而在他看来艺术(广义的诗)和艺术家则是担当这种冒险的不二人选，因为：

艺术就是真理的生成和发生……作为存在者之澄明和遮蔽，真理乃是通过诗意创造而发生的，凡艺术都是让存在者之真理到达而发生；一切艺术本质上都是诗。（《艺术作品的本源》）

虽然现代主义把创造曲解为骄横跋扈的天才活动，但艺术语言作为一种"存在者无蔽状态的道说"仍是我们进入无蔽状态和澄明之境的根本途径。艺术之所以具备这样的功能在于艺术具有追忆和沉思的本能，因而它在本质上既是体验性的又是历史性的：

作为创建的艺术本质上是历史性的。这不光是说：艺术拥有外在意义上的历史，它在时代的变迁中与其他许多事物一起出现，同时变化、消失，给历史学提供变化多端的景象。真正说来，艺术为历史建基；艺术乃是根本性意义上的历史。（同上）

魏言的艺术也具有这种"历史性"的特征，它始于"忧患"：物质和技术文化时代对人类心智和灵性的遮蔽与扭曲构成他艺术问题的基础，但他对这种存在现实的反思采取了一种历史化的图像描述方式，他在上古神话谱系和图像传统中直接提取符号资源，创造出一系列诡异而不乏灵性的超现实形象，正如梅洛-庞蒂将原始神话及象征符号作为研究人类心灵模式的有效途径一样，魏言创造的这些形象几乎也是现象学式的：它们既不是知觉世界的表象，也不是一种历史本质的呈现，它们既不分析也不解释，它通过描述"使事物返回本身"，为我们提供一种主体间性的体验："它们通过我过去的体验在我现在的体验中的再体现，他人在我的体验中的再现，形成它们的统一性"（梅洛-庞蒂）。

人类艺术思维的基本特征即是借助符号对自然和自我的象征思考，而技术和消费时代不仅制造了人与自然的紧张关系而且根本性地摧毁了人类想象的合法性，从而动摇了人类存在的根基，这

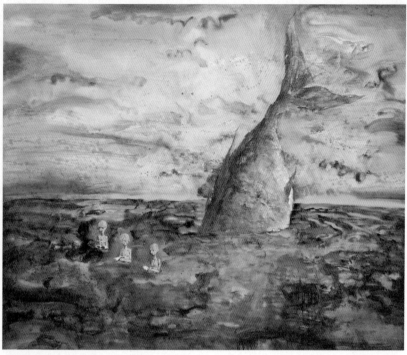

神圣思想，布面油画，180×150厘米，2007年
Sacred Thinking, Oil on canvas, 180×150cm, 2007

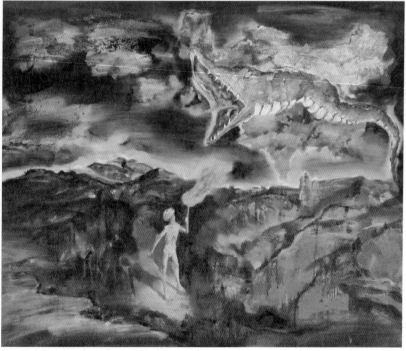

育蛇No.1，布面油画，180×150厘米，2005年
Yu-Snake No.1, Oil on canvas, 180×150cm, 2005

就是海德格尔以"深渊"和"贫困"描述我们时代的真意，而消费文化以平面化、复制化为美学特征的符号操控系统（它的艺术对应体系是波普、卡通、动漫等各种形式的图像风格）极大简化了艺术赖以发生的历史意识和主体意识。对魏言而言，神话形式的图像创造也许不仅仅构成一种反思现实的题材，也是一个激活人类灵性和想象力、恢复人与自然正当关系的过程，2007年艺术家在昆仑山口以仪式性的方式埋葬了他的"灵兽"，在一个特定的神话空间完成了这个类似海德格尔所说的"建立世界和制造大地"现代神话学叙事，从而使这一过程在这个名为"虫在昆仑"的艺术方案的实现中达到了高潮，艺术家对这一事件的回述也许可以验证我对他作品意义的猜测：

无论在中国的古代神话学、人类学和神话地理学，昆仑山都是一个中心概念，它在整个中国文化流传下来的神话谱系当中有着极其重要的位置，从字型发音到符号象征都引人深思，关于它所引发的神话原型、死亡观念、地理地质、宇宙观念、古代哲学生命崇拜系统、幽冥神话等等在中国远古文化学研究中都是非常重要的部分。而我的艺术创作则跟这些领域有着密切关联。这种冲动的萌发最早是在98年以后开始的，那时还在大学期间，在当代艺术呈现出来的种种现象及方法理论中，我一直没能找到可以说服自己的东西，相反胡塞尔的超验现象学和容格的原型心理学却深深吸引着我，后来几年的艺术创作一直被一种超验意志与现实生存之间所产生的不调和状况所折磨着。我总是试图去找寻一种与众不同的文化意义，在主流学术话语大量的纠缠在"消费"、"意识形态"、"生存状况""都市话语""伦理与社会"等等概念范畴的时候，我却在人类学和历史当中找寻源泉。我对当代艺术的不满足在于中国当代艺术创作的观念显得单一而刻板，尤其当代命题模式和解题模式比比皆是，大量的观念重复和语言

粘连，艺术正在丧失一种人类意义的独立和多元性能力。艺术思考的独立个性和鲜明特质远远不足。在经历对种种现象的研究之后，我认识到了当代艺术在智力想象方面的匮乏。在开始于05年的绘画作品中，我创造出了"灵兽"这类形象，并由此创作出了虫与果系列。"灵兽"这一形象是种符号象征性的表达，直接指向某种古老心智的美学范畴，象征着远古文化的某种自然灵性。

（《虫在昆仑——魏言艺术创作心路》）

魏言将自己的美学叙事称为"异述"：一种仍然来自于中国古代的志怪小说式的叙事方式，一种将神话与刺喻、杂议与清谈混于一炉的民间话语，这种美学针对的是艺术家身临其境的现实，当各种形式的消费时尚图像和虚假的政治道德姿态主导中国当代艺术时，一种与现实保持距离的历史美学态度也许反倒会促使我们思考一些真正与我们的人生和艺术相关的安身立命的问题。

魏言和他的同代人的作品中（如邱黯雄《新山海经》）出现的这种具有历史感的美学趣味，也许就他们所处的时代而言显得有些不合时宜，但我仍想将它们视为一个积极的征兆，如果运气好，它或许可以在中国当代艺术中催生出某种具有独立品质的新美学。

The Historical Aesthetics in Wei Yan's Art

Huang Zhuan

In the works of the young artist Wei Yan, the series taking "Lingshou" (Mystic Creature) as the subject matter, the contemporary narrative is given a new aesthetic form: a variety of contemporary issues is unfolded in the frame of ancient myth narrative; all kinds of surreal visual images usually create some special poetic intention, the "nostalgia" of the anthropological sense.

In order to understand the new aesthetic, we should first know the artistic issue the artist defaulted for himself--- finding 'spiritual' expression in the local mythology and anthropology. This default provides us a historical dimension for us to discuss his art. Let us experience his original intention through his own statements:

"… in today's material culture, the post-modern enlightenment makes the human being largely lose their potential cultural spirituality in the functional society, such as the abilities of perception and imagination including the ability of interpreting knowledge. People's lives are satisfied and they pursue the functional use of materials, but the emotional world became boring due to the mechanical and monotonous lifestyle. I attempt to express the different opinions through art, intending to awake and recall some minds to return to a natural-sensitive status and achieve the integrity of a "man". (Lingshou in Kunlun--- Wei Yan's Statement of Artistic Creation)

The late Heidegger turned the metaphysical thinking of existence to the question of "poem-thinking" : the material culture and the technological era having God removed make people fall in the abyss. Only "the poet of the poor times" can arouse people's memory of the natural life and the essence of existence, to find out the traces of the gods fading away and understand the meanings of "heaven" and "earth" , which makes people become "open" without shelter. It's almost the must "adventure" people have to take to save them. (What Can Poet Do) In his view, art (poem in a broad sense) and artists are the exclusive

candidates to take this risk, because:

"Art is the generation and occurrence of truth… As the being's clarity and shelter, the truth is generated by poetry. All art is to allow the truth of existence achieve and generate; all art is essentially poetry. (The Origin of Artworks)

Although modernism distorts creation as the arrogant and despotic events of geniuses, the art language as "the Tao of the being's unsheltered status" is still the fundamental approach for us to enter into the unsheltered and clarifying state. The reason why art has such function is that art has the instinct of remembrance and mediation, so it is essentially of experience and history:

"Art as creation is essentially historical. It not only means art has history of the external sense. In the changing times, it occurs with many other things, changing and disappearing, providing diverse scenes for history. Indeed, art founds the foundation for history; art is the history of a fundamental sense. (Ibid.)"

Wei Yan's art also has this "historical" characteristic. It begins with "anxiety" : the shelter and distortion of human's mind and spirit caused by the era of material and technical culture constitute the basis of his art issue. But he adopts a historical picture description for the reflection of existence. He picks up symbolic source from the ancient mythology pedigree and traditional images to create a series of bizarre and spiritual surreal image. Like Merleau Ponty taking original symbols of myth as the effective way to study human soul, the images Wei Yan created are also phenomenological: they are neither the appearances of the perception world nor the presentation of the historical essence. They are neither analysis nor explanation. By description, it "makes things return to themselves" , providing us an inter-subjective experience, "through the reproduction of my past experience in my

current experience and the reproduction of the others in my experience, they form their unity." (Merleau Ponty)

The basic characteristic of human artistic thinking is the symbolic thinking of nature and self by the use of symbols. However, the era of technology and consumption not only produces the tense relation between man and nature, but also fundamentally destroys the legitimacy of human imagination, which has shaken the foundation of human existence. This is the true meaning that Heidegger uses "abyss" and "poor" to describe our era. The aesthetic characteristics of the consumer culture's symbol-control-system are of planarization and copy (corresponding arts are pop art, cartoon, animation and picture style of various forms). It greatly simplifies the historical consciousness and subject consciousness that art relies on. For Wei Yan, the creation of mythic images is not only for constituting a theme reflecting reality, but also a process activating human spirit and imagination, restoring the proper relation between man and nature. In 2007, in the Kunlun Mountain, the artist buried his "Lingshou" in a ceremonial manner. In a specific mythic space, he completed this modern mythology narrative like that Heidegger called "build world and produce earth", which makes the process achieve the climax in the realization of the art project named "Lingshou in Kunlun". The artist's statement of this event may verify my guess of the significance of his works:

"In ancient Chinese mythology, anthropology and myth-geography, the Kunlun Mountain is a central concept. It occupies an extremely important position in the myth pedigree of Chinese legacy. Its font, pronunciation and symbol attract people to think profoundly. The myth prototype, the concept of death, the geography and geology, the concept of universe, the life worship of the ancient philosophy, and the ghosts and myths caused by it are very important parts in the Chinese ancient culture study. My art creation has close relation with these areas. The germination of the impulse began in 1998 when I was in university. Among the various phenomena and theories of contemporary art, I couldn't find anything to convince myself. On the contrary, Husserl's transcendental phenomenology and Jung's prototype-psychology attracted me a lot. The creation of the later years is always tortured by the unharmonious status between the transcendental will and the real existence. I always try to find a unique cultural significance. When the mainstream of academic discourse is entangled with the concepts and categories such as "consumer", "ideology", "living

conditions", "urban discourse", "ethics and society" and so on, I was looking for the source in anthropology and history. I am unsatisfied with the phenomena contemporary art because the concepts of Chinese contemporary art are monotonous and rigid. In particular, the contemporary proposition models and the problem-solving modes are everywhere; a large number of concepts are repeated and language is adhesive; art is losing the ability of independence and diversity. The independent personalities and the distinctive characteristics on art thoughts are far from adequate. After the study of the various phenomena, I realize the contemporary art is short of intellectual imagination. In the painting began in 2005, I created the image of "Lingshou", and thus created the series of Lingshou and fruits. The image of "Lingshou" is a symbolic expression, directly aiming to the aesthetics of some ancient mind and symbolizing a natural spirituality of ancient culture." (Lingshou in Kunlun--- Wei Yan's Statement of Artistic Creation)

Wei Yan names his aesthetic narrative as "Alternative Reference", a narrative way from the ancient Chinese ghost stories, the civil discourse mixed with myth, metaphor, miscellaneous discussion and talk. This aesthetics aims at the reality the artist immerses in. When the various forms of images of consumption and fashion, and the false political and moral attitudes guide the Chinese contemporary art, a historical aesthetic attitude keeping distance from reality may lead us to think some basic issues really related to our life and art.

The historical aesthetics appeared in the works of Wei Yan and the artists of his generation (such as Qiu Anxiong's New Book of Mountains and Seas) may seem somewhat outdated in terms of their era. But I still would like to see them as a positive sign. If lucky, it might give birth to some new aesthetics with independent quality in Chinese contemporary art.

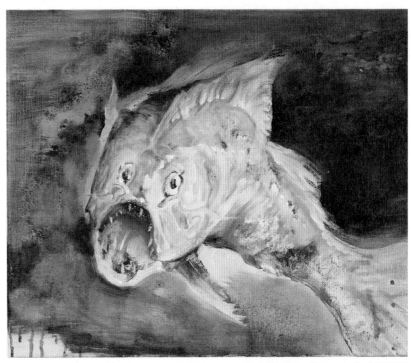

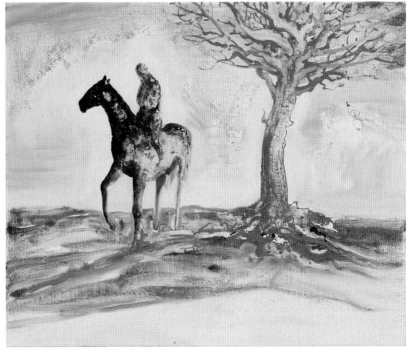

油画小稿，布面油画，50×60厘米，2009年
No Title, Oil on canvas, 50×60cm, 2009

21

个人历史的另一面

......魏言访谈

吴蔚

吴蔚（以下简称"吴"）：相比你以前较为"哲学化"的作品，你的新作在绘画气质与情绪上发生了变化，它们是怎么开始的？

魏言（以下简称"魏"）：我的艺术概念一直围绕远古神话和民间杂谈叙事来进行。2004年，我到敦煌考察，随后从2005年开始创作"神话"系列、"虫与果"系列和以植物为题材的作品。去年"5·12地震"后，我更关注普通人的微观历史和具体处境，因此在新的绘画构思上，更多偏重于个体经验，有些从命名上就可以看出，如《聊斋——宋唯计划》、《戊子年的老蒋》等。

吴：《戊子年的老蒋》似乎是你第一次将某个人作为绘画的主角？过去的人物大多以符号化的形象出现在你的作品里。

魏：人从符号性象征变为主体表达，这种变化也许受到现实观念的驱动。老蒋是我工作室对面的画家，从各方面说他都和我们一样，是一个很普通的人，一种不需要文学修辞和藻饰的生存状

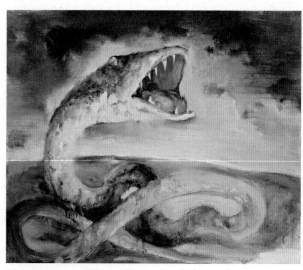

油画小稿，布面油画，50×60厘米，2009年
No Title, Oil on canvas, 50×60cm, 2009

态，这种状态对我而言比"真实"这个概念更可信，这就是"一个人的历史"。这样的感受也许在以前被忽略了，但地震给我的启发是，每个人的生命进程和具体处境都有可能与宏大的历史叙事发生关系，建立一种经验结构。过去的创作完全停留在主观想象层面，现在我想要将它与现实生活中真实而具体的"个人历史"结合起来，并开始在具体的当代情境中寻找一种架构关系。

吴：你以前的画主要基于逻辑和意念，现在开始具有临场的现实意义，是否可以将之理解为你所说的"架构关系"的开始？

魏：如果说历史的、线性的发展构成了Y轴，当代的、同时性的发生形成了X轴，两轴交汇就是今天发生学意义上的认识标准和知识结构，我的作品就是希望找到这种坐标关系，将当代的经验、情绪纳入历史框架中去考察和认知。

吴：你认识和建立这种坐标关系的基础是什么？

魏：2004年以前我所研究的哲学、美学几乎全是西方的，很少接触中国的古代文献。从大学开始，我深受西方马克思主义的影响，阅读了大量霍克海默、哈贝马斯、茵加登，以及马尔库塞的著作，对马克思以后的社会批判理论和新左派运动很感兴趣。

2004年，我带学生去敦煌考察，敦煌壁画对我的震撼非常大，有种幡然醒悟的感觉。在此之后，我开始思考东方文化特质与民族性的问题，而我同时意识到这一代人的个人命运是在一个大的历史背景下展开的，必须面对的是社会转型过程中所带来的文化的对撞与身份认同等问题。敦煌之行虽然没有让我形成理论上的梳理，但这种深刻的感触让我认识到什么才是好的东西，这在最初完全是某种感性经验。在后来的思考中，我才明确了"具有文化根性"才是我需要的当代艺术。也可以说，我采用西方体系化的方法论，但研究的对象和结果还是东方文化的特质，并且我越发感到当代文化需要建立一种历史意识的认识。

吴：你认为应该如何用视觉的方式来表达"历史意识"？

魏：不是用什么方式去表达"历史意识"，而是带着历史意识去表达"什么"，历史意识只是作品背后的理念或称之为"背景"的东西。从1990年代初起，当代美学和艺术流向就开始在抵触一种历史的深度，在漫画和浅显的趣味上游走，以肤浅社会批判意识为噱头的复制性美学和衍生性美学占据了艺术的主流，加上市场的鼓噪。这必然要加重对其如此发展下去的反思。我们在什么时候偏离了先锋性学术的发展预期？在怎样的时代性语境下发生了错位？我们有可能造成怎样的历史误解而会面临更大的麻烦？简单说来，就是理清文化创作上的明线和暗线。这样我们就不会落入流行文化和样式美学的巢窝，也不会头重脚轻、心急火燎地去与国际接轨了。与思想问题相比，视觉方式是个次要问题，是解决问题和制造问题的方法论。

吴：在你的作品中，理论所起的作用很重要吗？

魏：在复杂的信息技术条件下，对当代艺术的了解和掌握都必须要首先对其语境和文化结构上进行研究，理论研究起到了很重要的作用。今天年轻画家们热衷于谈论新莱比锡画派、意大利"3C"、马克·奎因或马修·巴尼，但不可只停留在视觉表象上，进行相关的哲学和美学研究会起到很重要的认识作用，这是我的看法。当你认识到村上隆的艺术背后包含着整个日本相对于美国的文化产业而进行的文化输出策略和主体对话机制的努力探求，并为这种后殖民语境下的文化生存处境提供了一个鲜明的精神文本时，你才能够明白村上隆的艺术成就绝不仅仅是提供一种视觉样式这么简单。我同意村上隆的观点，作为一名专业艺术创业者，我们必须要具备专业研发能力，理论研究是很重要的工具，只有在认识中去牢牢掌握今天艺术的内在脉络，才能最终创作出与众不同的优秀作品来。但需要强调的是，这与每天在工作室的画布上要面对的东西没有直接关系，它只是你在作品背后要思考的东西。

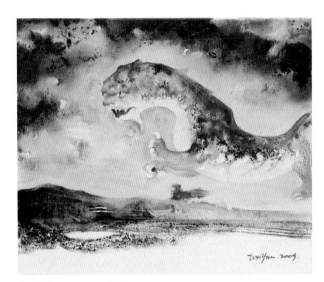

油画小稿，布面油画，50×60厘米，2009年
No Title, Oil on canvas, 50×60cm, 2009

吴：我们知道，当个人化的臆想难以产生感染力时，其历史性存在的意义就已经阻断了。

魏：是这样的，个人化的臆想从来不能打动观众，让我们感动只有根据这种臆想而构思创作出来的艺术。个人化的臆想对个人来说有历史性存在意义，但如果过多地注重这种个人化臆想而忽略了表达的语言性和媒介客体，其表达的意图就会发生误解、扭曲或者阻隔。

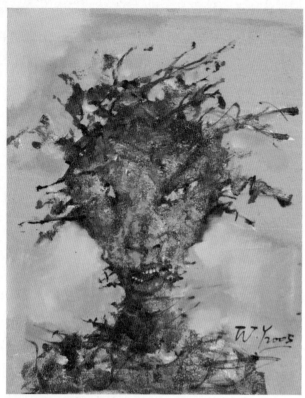

三苗，布面油画，50×40厘米，2005年
San Miao, Oil on canvas, 50×40cm, 2005

吴：具体来说，你画画的过程是怎样的？

魏：一开始是一个泼的过程。我先在画布上制作肌理，待到被稀释的油画颜料泼上去后，先前塑造好的肌理会影响油的流淌方向，会阻挡和诱导它。加之我画室的地面凹凸不平，平躺的画布可能朝一边倾斜，有时需要我去不断调整，过程中的效果是无法事先设想的。最初我能明确的只是基本的构图形式，色彩和细节在这一阶段是无法把握的。随后我再在里面去剔除，去添加，去发现一种秩序，而不是预设一种主观性的意图。有时，各种想要实现的欲望会紧紧纠缠在一起，你永远不知道最后会形成什么。我要做的，只是在这种偶然过程中去发现和搜集我的欲望，接受和否定它们，让它们消失或让其中部分留存在画面。

吴：你最终还是服从于某种不确定性因素？作为画家，你怎样把握你的作品？

魏：事实上，发现与建立秩序的过程是非常理性的思维过程。因为你面对的是一片混乱，你需要很冷静地去分析和判断哪些应该被取舍，这实际上是一个很复杂而敏感的结构过程。一开始你需要一种偶然性，但后来也要重新去寻找作品的结构与平衡。

吴：《聊斋——宋唯计划》的空间效果很突出，肥硕的仙人掌与强烈的光影让人不安，墙上闭眼的人像则显露出疏离和痛苦。它们似乎在一开始就阻止了人们的进入。除此之外，你想表达的是什么？

魏：创作这件作品源自我对一个朋友的了解。他的境遇，他特有的懦弱，以及对人的真诚都让我感觉他既真实又复杂的人性内容。他的现实遭遇让我联想到沙漠植物的处境，这世上有许多的人与现实格格不入，看上去缺乏与社会交往的能力，但仍然坚持自己的意见和对生活的看法，我企图将这种生存状态以"数据化"的方式记录下来。人与植物，这两种精神状态是相关的。我也专门测量了他的身体数据，然后喷到植物上去，这只是一种记录方式。我认为用数字记录对存在的表达更真实，具有唯一性。

吴：人类中心论的幻觉在某种程度上遮蔽了人与自然之间关系。你作品中的植物是欲望的主体，它们仿佛在有意识地不断自我复制、繁殖和生长，直至掌控世界。

魏：我对植物的描绘都是想象性的，没有具体参照。植物的形态让我着迷，植物的生命形式比人更具有多样性，它们对环境的敏感度也比人更高，其生长周期也很明显。植物也许是最古老的一种巫术观念与神话信仰，它也是最早的一种欲望形式，即生存和繁殖。在今天这个后工业时代，尤其是面对诸多的环境问题，植物与人的关系需要重新按照某种原始的转换方式来对待，重新定义人与自然的平衡。这其中还涉及一个身份问题。按照德勒兹的观点来看待动物与人的区别，我们只能从生物学上的特征来界定人，但就欲望而言，这二者并无区别。现代社会所造就的人也许比植物更缺乏生命力。从根本上讲，欲望是每位艺术家创作的原动力，只是对欲望的意义和实现方式有所差别。

吴：你还选取了一位"旁观者"，可以说灵兽是你的意识投射体吗？

魏：我在画灵兽时，很多时候都在认同自己的感觉，也与这个形象建立起了无间的亲密和信任，让我感觉安全。"灵兽"系列画了十几张，尽管我很喜欢这个形象，但我不想形成某种依赖，特别是对图像符号的依赖，这对年轻艺术家是不必要的，违背了艺术家对自由的追求。

吴：所以你把它埋到了昆仑山下？

魏：对，过十年再挖出来。当时是带着某种情绪做了《虫在昆仑》，将它带到昆仑山，埋到了一个让自己感觉很安全的地方。这件作品也许从自身的解读上没有什么深刻和复杂的逻辑，但它

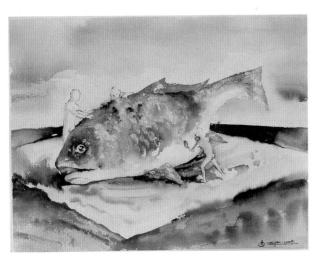

人鱼杂志，纸本水彩，50×60厘米，2009年
Merman Notes, Watercolor on Paper, 50×60cm, 2009

对我而言具有一种仪式化的意义。

吴：有意思的是，在《希望源于信任》这张画中，画中人所面对的风景被阻隔了，就好像你在标题里所表达的愿望未能实现。

魏：这是我对未来的寓言。"未来"其实就在我们返观自身之中。画面上，人前面的区域类似于一面镜子，那句英文是反写的，只有在镜中才能看到正题，这也是一种"返观"的历史意识的表达。我们总在设想未来，但未来也许正是在某种反观中被了解和认识的。另外，我一直对时间感兴趣，在我看来，过去就是未来，未来即是过去。我并不太认同线性的时间观，时空和记忆总是在发生扭曲和错乱。

吴：你向往一种更自由的精神维度，或者说更有力度的语言方式。这也是你目前作品所面临的问题。

魏：目前的问题在于我不可以长时间停留在当下的认识里，当下只是一个受限的时空形式，依靠已形成的艺术认识上去猜测今后要面对的状况是不可取的，必须要不断地寻找和实验新的思想和出路。在千万条思路中找到一条，以无比的勇气和耐心去深入和相信它，直至我找到实现艺术意图的通道和方法。

吴：你试图传达的思想是什么？

魏：我想要传达的思想就包含在这次个展的命名中——"异述"，其英文"Alternative Reference"含有另类参照的涵义。我想找到另外一种理解当代艺术的坐标和参照系。它比较民间化、乡野化，是另一种知识参照下的讲述，近乎于口语和杂谈，因此

有很大的想象性和生命力，是现实生命经验的一种异样感。这种美学上的新主张，黄专先生定义为"历史美学"，与时下主流文化话语体系相去甚远，这将是一个长期过程。所以，我的个人处境有时候也很尴尬，比如在商业画廊举办个展，这是一个与主流不悖逆的文化话语场，但实际上我的许多想法和主张是在反这个主流话语系统的，个人追求上有悖于其价值和方法。对我而言，孤独其实不可怕，尴尬很可怕。有人会以错误的方式理解你，并且认定这是理解你的唯一渠道。

吴：这种尴尬经常出现吗？

魏：它正在发生……

吴：你如何应对这种处境？

魏：我需要寻求更多的力量支撑，特别是强大的内心。当面对当今的各种话语，在与主流文化相悖的背景下，要培养自己的勇气。这种尴尬状况会不断提醒你，你还没有彻底地表达自己。

The Other Side of
A Personal History
— *An Interview with Wei Yan*

Wu Wei

Wu Wei (hereinafter referred to as "Wu"): Compared with your previous "philosophical" works, your new works have changed on the temperaments and emotions of painting. How did they begin?

Wei Yan (hereinafter referred to as "Wei"): My concept is always around ancient myths and folk narration. In 2004, I went to Dunhuang for study. Since 2005, I have started with the series of "Myth", "Lingshou and Fruits" and some other works with plants as the theme. Since the "5.12 Earthquake", I have paid more attentions to the micro-histories of the ordinary people and the particular situations. Therefore, the construction of new paintings emphasizes individual experience, With the names such as "Liaozhai--- Project Song Wei", "Laojiang of Wuzi Year", etc.

Wu: "Laojiang of Wuzi Year" seems to be the first time you take a person as the subject? Most figures of your past works appeared as symbolic images.

Wei: The change from symbols to expression of subject may be driven by the realistic concept. Laojiang is the painter living in front of my studio. Just like us, he is an ordinary person in a state that doesn't need rhetoric expression. For me this state has more credibility than the notion of "truth". This is "a personal history". This kind of feeling might be ignored in the past. But the inspiration the earthquake is that everyone's life given by and situation can be related to the grand historical narrative and form a structure of experience. The creation in the past remained subjective and imaginative. Now I want to combine it with the real and specific "personal history" to find a structural relation in the concrete contemporary situation.

Wu: Your previous paintings are based on logic and intention. Now you have the on-site reality. Can we regard it as the beginning of the "structural relation" you mentioned?
Wei: If the diachronic and linear development forms the Y-axis and the contemporary and synchronic occurrence

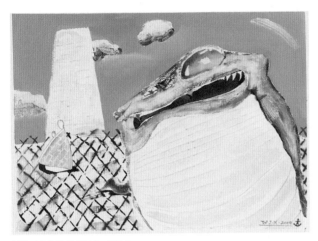

无题, 纸本水彩, 40x50厘米, 2004年
No Title, Watercolor on Paper, 40x50cm, 2004

forms the X-axis, the intersection of the two-axis is the standards of knowledge structure of today's occurrence study. My work is to find this relationship in coordinates, to investigate the contemporary experience and emotions in the historical framework.

Wu: What's the base of the relationship in coordinates you recognized and built up?

Wei: Before 2004, almost all of the philosophies and aesthetics I studied were western. I rarely touched the Chinese ancient literature. In college, I was deeply impacted by Western Marxism. I read the books of Horkheimer, Habermas, Ingarden and Marcuse, with great interests in the New Left movement and the social criticism of Post-Marxism.

In 2004, I brought my students to Dunhuang. Dunhuang murals have greatly shocked me and woke me up. After that, I started to think the characteristics of oriental culture and nation. At the same time, I realized personal fate of this generation is in the large historical background. We have to face the cultural collision and the identity issues in the process of social transformation. The trip to Dunhuang didn't bring me the theoretical system, but I've been deeply touched and realized what good thing is. Originally, this is a kind of perceptual experience. In the later thinking, I am clear that the contemporary art I must "have base of culture". In

other words, I use the western systematical methodology, but the objects and results of my study are about oriental culture. I feel more and more the need to establish cognition of historical awareness in the contemporary culture.

Wu: What's your opinion about how to express "historical awareness" visually?

Wei: It's not to express "historical awareness" in some means, but to bring historical awareness to express "something". Historical awareness is the ideas behind works or just "background". Sine the early 1990s, the contemporary aesthetics and artistic trends begin to turn against the historical depth, wandering on cartoons and superficial interests. The copied aesthetics and derivative aesthetics taking the superficial social criticism as gimmick, have occupied the mainstream of art, pushed by the market. This is bound to the reflection of the development of this trend. When did we deviate from the expectation of vanguard academic development? What is the time of the dislocation? What kind of historical misunderstanding is going to bring us greater trouble? To take it simply, it's about sorting out the unhidden and hidden lines of cultural creation, so that we will not fall into popular culture and stylistic aesthetics and won't be so rushed to connect with the international trend. Compared with the thinking issues, visual style is a secondary issue and is the methodology solving and creating problems.

Wu: Does theory play a very important role in your creation?

Wei: In the complex condition of information, the research of contemporary art has to study the context and cultural structure first, so the theory study has a very important role. Today, the young artists prefer the New Leipzig School, Italian "3C", Mark Quinn or Matthew Barney, but we cannot only stay in the level of visual appearance. The related philosophical and aesthetical study will play an important role. This is my view. When

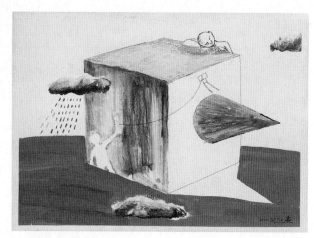

无题, 纸本水彩, 40×50厘米, 2004年
No Title, Watercolor on Paper, 40×50cm, 2004

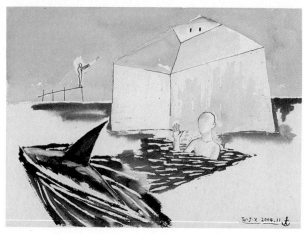

无题, 纸本水彩, 40×50厘米, 2004年
No Title, Watercolor on Paper, 40×50cm, 2004

you realize the art of Takashi Murakami includes the cultural output strategy and the efforts of communication that has Japan has paid in front of the American cultural industry for its cultural existence of post-colonial situation, you can understand the achievement of Takashi Murakami's art is not only so simple as providing a visual pattern. I agree with Takashi Murakami's view that as professional artists we must have professional capabilities of research and development. Theoretical research is a very important tool. Only by firmly grasping the inner context of today's art can we ultimately create the unique and outstanding works. What has to be emphasized is that it has no direct relation with what we have to face on canvas in studio everyday. It's just

something you have to think behind the works.

Wu: We know that when personal speculation is unlikely to generate infection, the significance of the historic existence has been blocked.

Wei: It's just like that. Personal speculations never move audiences. Only the art created by the speculations can move us. Personal speculations have the significance of historic existence to individuals, but if there are too many emphasizes on the personal speculations that neglect the language of expression and the object of media, the intention expressed will be misunderstood, distorted and blocked.

Wu: Concretely speaking, how is the process of your painting ?

Wei: It started from splash. First, I create texture on the canvas, and then splash the diluted paintings on it. The shaped texture will influence the direction of the oil, How by blocking or inducing it. In addition, the ground of my studio is rugged. The flat canvas on in could be inclined to one side. Sometimes I have to continuously adjust it. The effects in the process cannot be previewed in advance. Initially, I am only able to design the basic composition, but unable to assume colors and details at this stage. Then I try to find another order by deducting or adding something without any subjective intention. Sometimes, a variety of desires will be tightly entangled. You never know what will be formed. What I want to do is to find and collect my desires in this process of chance, accepting and neglecting them, making them disappear or retaining part of them in the screen.

Wu: Are you ultimately subject to some uncertain elements? As a painter, how do you control your works?

Wei: In fact, the process of establishing order is a very rational. Because I face chaos, I have to analyze and judge to make choice. Actually, this is a complex and sensitive structural process. At the beginning, you need a chance, and later you have to look for the structure and

balance of the works.

Wu: The spatial effect of "Strange Stories (Liaozai)---Song Wei Plan" is very outstanding. The stout cactus and the strong light are disturbing. The portrait on the wall with eyes closed reveals alienation and pain. They seem to stop people's entrances from the beginning. In this case, what would you like to express?
Wei: This work is inspired by one of my friends. His situation, his unique cowardice, and his sincerity make me feel his nature real and complex. I like to associate his real experience to the situation of desert plants. There are many people out of tune with reality. They are lack of social ability but insist on their own ideas and opinions of life. I try to record the conditions by "data". People and plant, the two mental states are related. I am also devoted to measuring his physical data and spray them on plants. This is only a manner of record. I think the expression of existence recorded by data is more reliable and unique.

Wu: The illusion of human-centered theory shelters the relation between man and nature. The plants in your works are the subjects of desire. They seem to constantly copy themselves consciously, reproduce and grow until they control the world.
Wei: My description of plant is by imagination, without concrete reference. The forms of plants fascinate me. The life style of plants is more diverse than that of people. They are more sensitive to the environment and their growth cycle is obvious. Plant may be the most ancient witchcraft and mythic belief. It is the earliest form of desire, survival and reproduction. In today's post-industrial era, especially in front of many environmental problems, the relationship between plants and people require to be re-treated in conversion, The balance between people and nature is to be redefined. This also involves the issue of identity. According to Deleuze, the distinction between animals and people can only be defined by the biological characteristics, For desire, they are the same. Man created by modern society has less

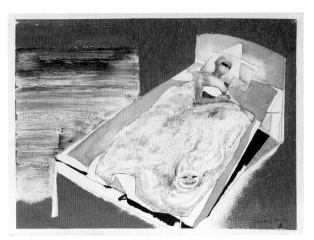

无题, 纸本水彩, 40×50厘米, 2004年
No Title, Watercolor on Paper, 40×50cm, 2004

vitality than plants. In fact, desire is the original driving force of every artist. The difference only exists in the satisfaction of desire.

Wu: You chose another "spectator". Is Lingshou the projection of your consciousness?
Wei: When I am painting Lingshou, I often identify my own feeling to and establish intimacy and trust with this image, as it makes me feel safe. The "Lingshou" series has dozens. Although I like this image, I don't want to depend on it, especially on symbols which is unnecessary for young artists and against to the freedom they pursue.

Wu: So you buried it in the Kunlun Mountain?
Wei: Yeah, it will be dug out after ten years. I was in this kind of emotion to do "Lingshou in Kunlun", brought it to the Kunlun Mountain and buried it in a place that I feel safe. No profound or complicated logic can be interpretation from this work, but for me it has a ritual significance.

Wu: It is interesting that in Hope Derives from Trust, the landscape the people in the painting faces is blocked. It is like that the will you express in the title is not realized.
Wei: This is the fable I made for the future. In fact, "future" is in the reflection of ourselves. In the screen,

the field before people is like a mirror. That English sentence is written conversely. Only in the mirror, we can see it correctly. This is also a kind of "back view" of the expression of historical awareness. We always anticipate the future, but the future only can be understood and cognized in some kind of reflection. What's more, I have always been interested by time. In my view, the past is the future and the future is the past. I don't agree with the linear concept of time. Space-time and memory are always distorted and disordered.

Wu: You yearn for a free spiritual dimension or a stronger language. This is also the problem your current works are facing.

Wei: The problem is that I cannot remain in the current idea for a long time. The present is only a limited form of space-time. Speculating the future situations by the formed artistic cognition is undesirable. We should continuously look for new ideas and examine it, find a right one out of millions of others, we need courage and patience until we find the approaches and methods to realize artistic intention.

Wu: What is the idea you try to convey?

Wei: The idea I want to convey is included in the name of the exhibition "Alternative Reference". I want to find another coordinate and reference to understand contemporary art. It is relatively folk and countryside. It's a kind of statement according to another knowledge reference, close to oral talk, therefore it has a lot of imagination and vitality and a strange sense of the experience of reality and life. Mr. Huang Zhuan defines the new aesthetic idea as "historical aesthetics". Different with the current mainstream cultural discourse, it will be a long-term process. Therefore, sometimes I am very embarrassed, for example, holding solo-exhibition in a commercial gallery is of a cultural discourse of the mainstream, but actually many of my thoughts are opposite to it. My personal pursuit is against its value

and methods. For me, loneliness is not terrible, but embarrassment is terrible. Some people will understand you in a wrong way and believe it's the only way.

Wu: Does this embarrassment often happen?
Wei: It is happening⋯

Wu: How do you deal with this situation?
Wei: I need more strength to support myself, especially the strong heart. In front of various discourses, in the background against the mainstream culture, I have to cultivate my courage. This embarrassing situation will continuously remind me that I haven't quite expressed myself to the core.

Plates

《上古传说》系列
"Ancient Legends" Series
2005~2007

第一条鱼，布面油画，165×200厘米，2007年
The First Fish, Oil on canvas, 165×200cm, 2007

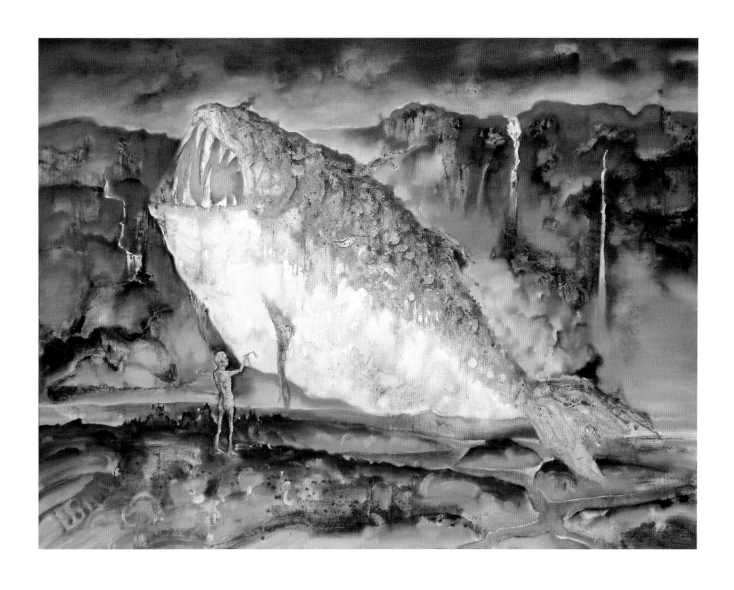

浮出水面的鱼见到了传说中的火，布面油画，120×190厘米，2007年
The Fish Surfacing Meets the Legendary Fire, Oil on canvas, 120×190cm, 2007

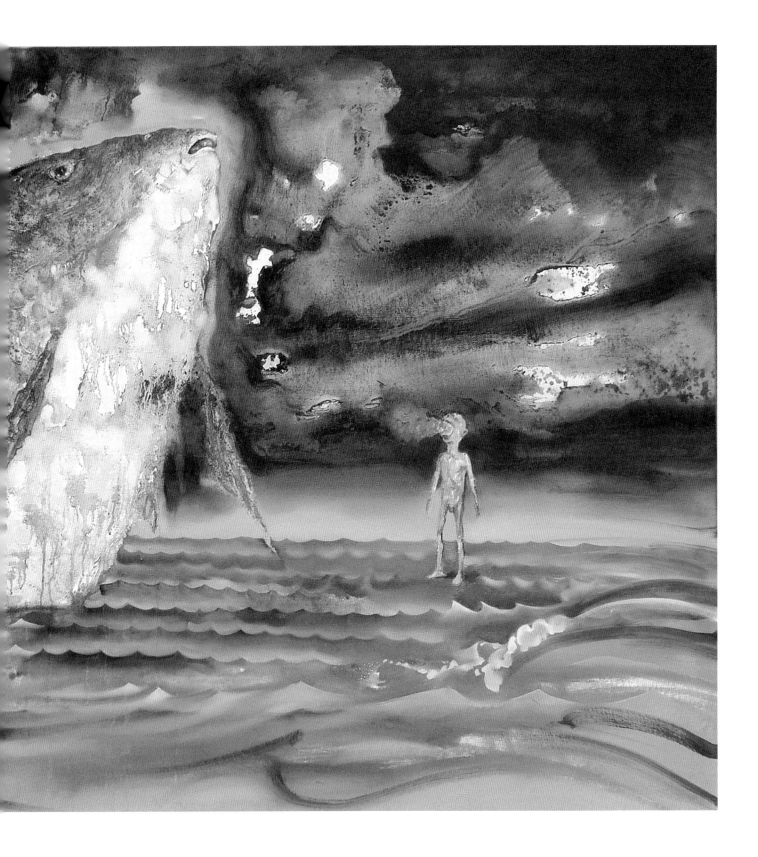

崇高的行为吸引了龙，布面油画，165×200厘米，2007年
Noble Acts Attract Dragon, Oil on canvas, 165×200cm, 2007

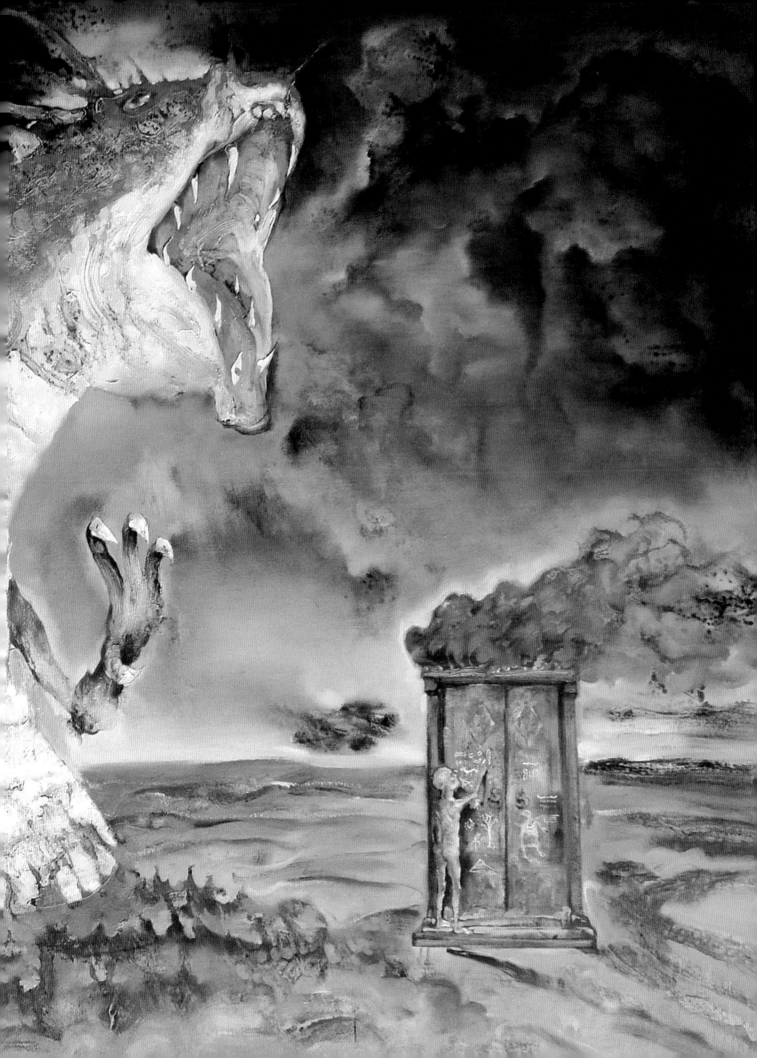

红海红鱼，布面油画，160×200厘米，2008年
Red Fish and Red Sea, Oil on canvas, 160×200cm, 2008

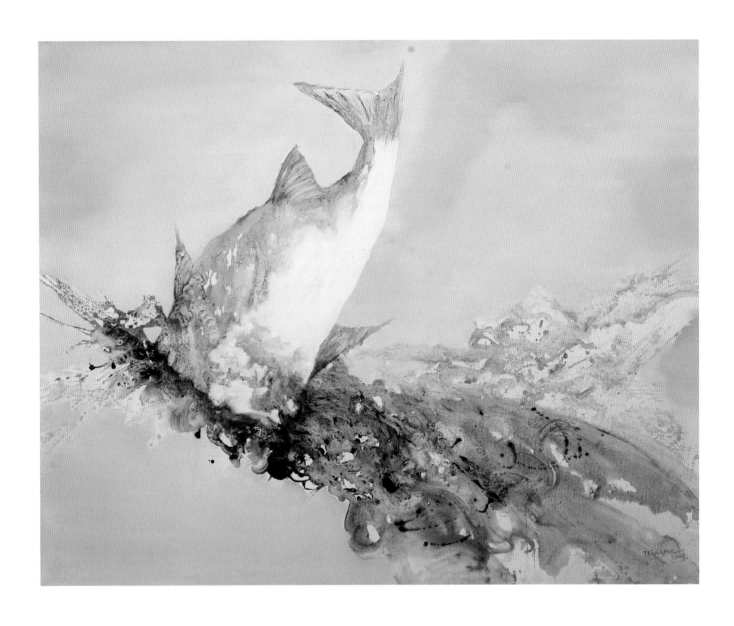

红龙No.2，布面油画，150×180厘米，2005年
The Red Dragon No.2, Oil on canvas, 150×180cm, 2005

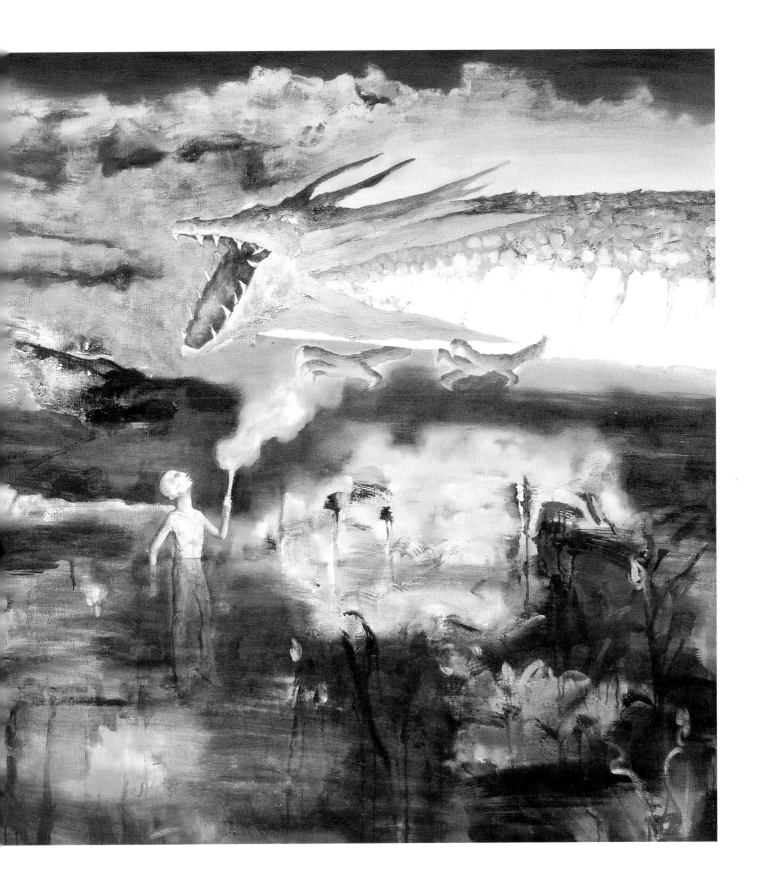

上古传说-红鱼，布面油画180×150厘米，2005年
Ancient Legends-Red Fish, Oil on canvas, 180×150cm, 2005

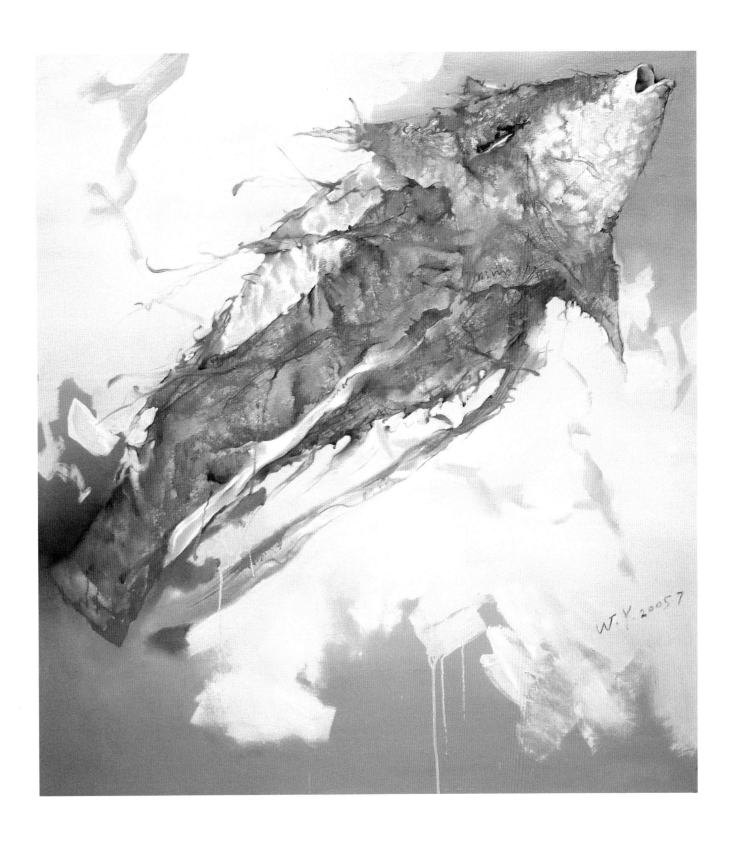

蜻蛾，布面油画，150×140厘米，2005年
Qing E Moth, Oil on canvas, 150×140cm, 2005

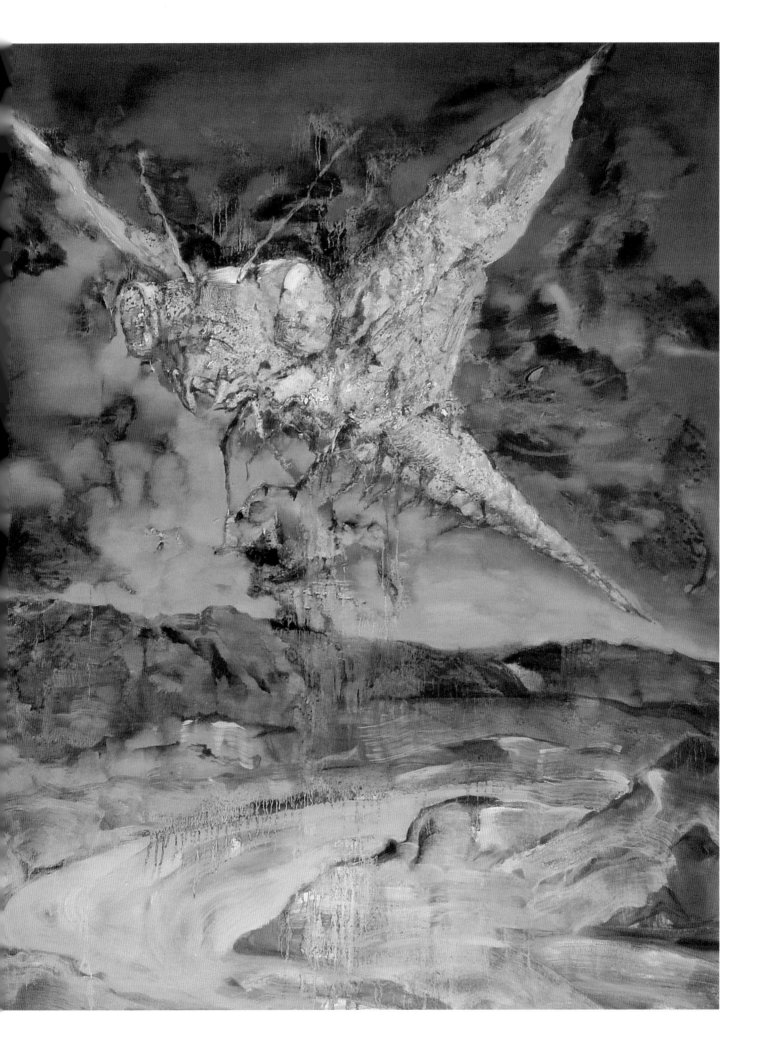

Plates

《虫与果》系列
"Lingshou and Fruits" Series
2005~2007

虫子出行在白天，布面油画，150×180厘米，2007年
Travel in the daytime, Oil on canvas, 150×180cm, 2007

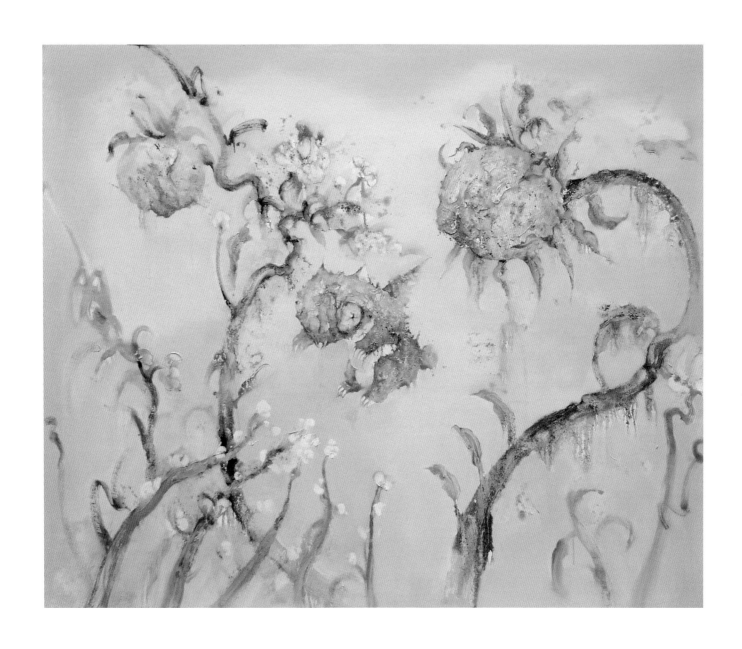

天使的出现，布面油画，150×180厘米，2007年
Angel appeard, Oil on canvas, 150×180cm, 2007

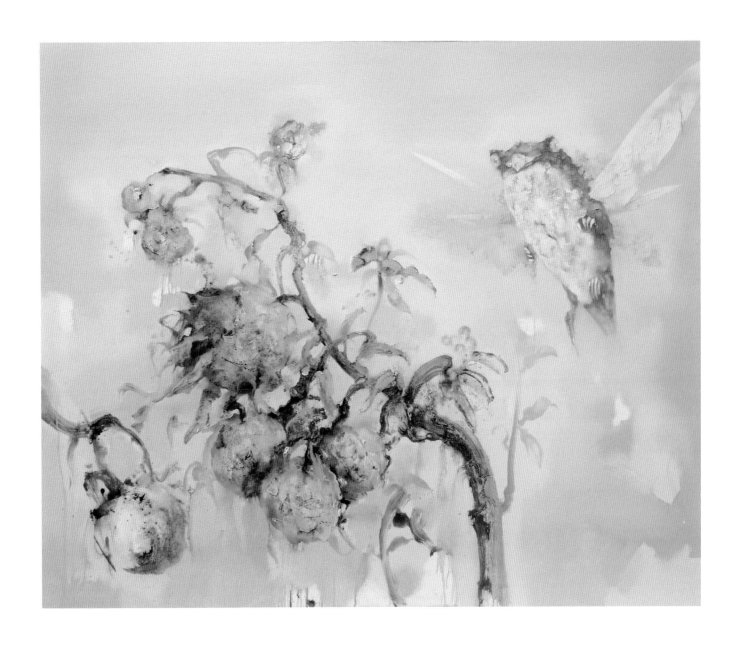

我守护的花开了，布面油画，150×140厘米，2006年
The Flowers I Guard are Blooming, Oil on canvas, 150×140cm, 2006

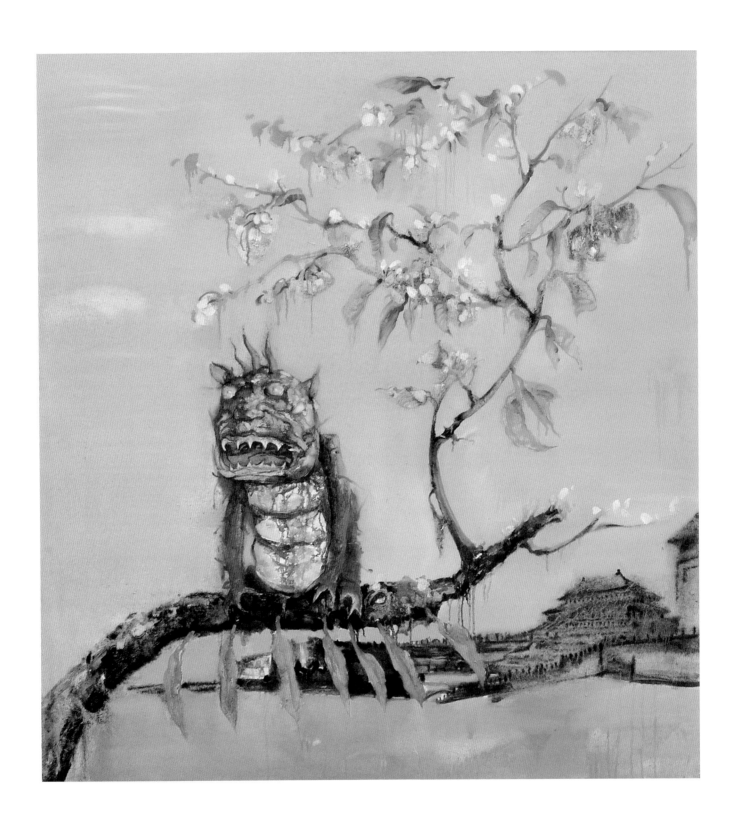

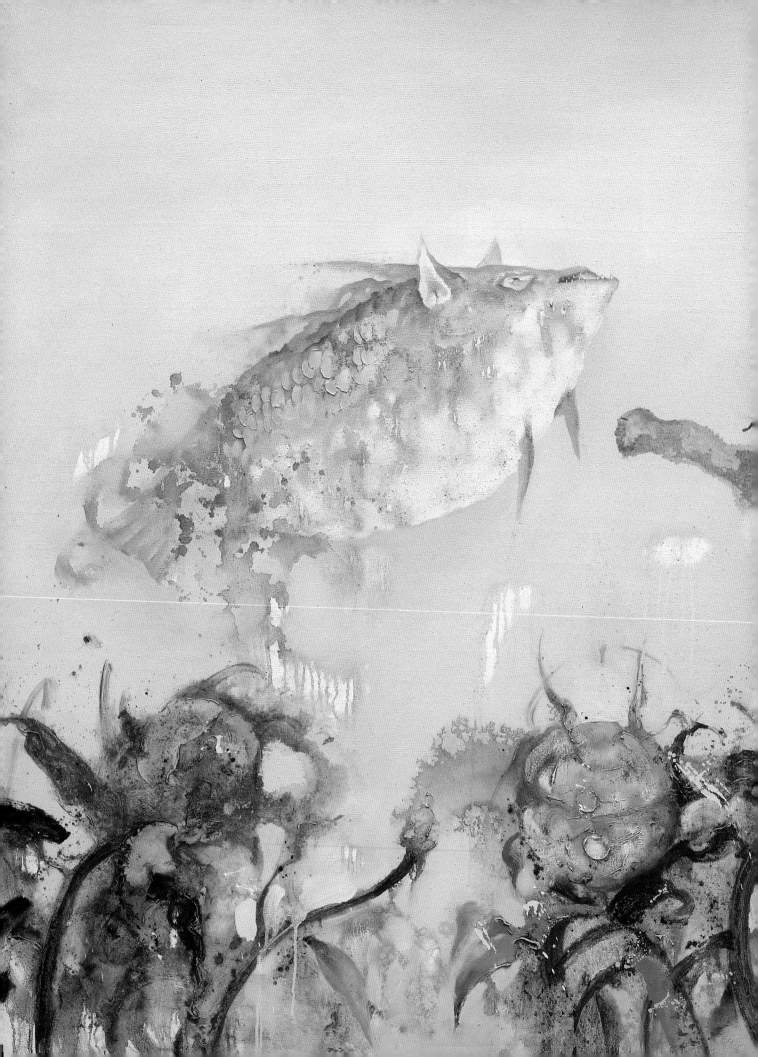

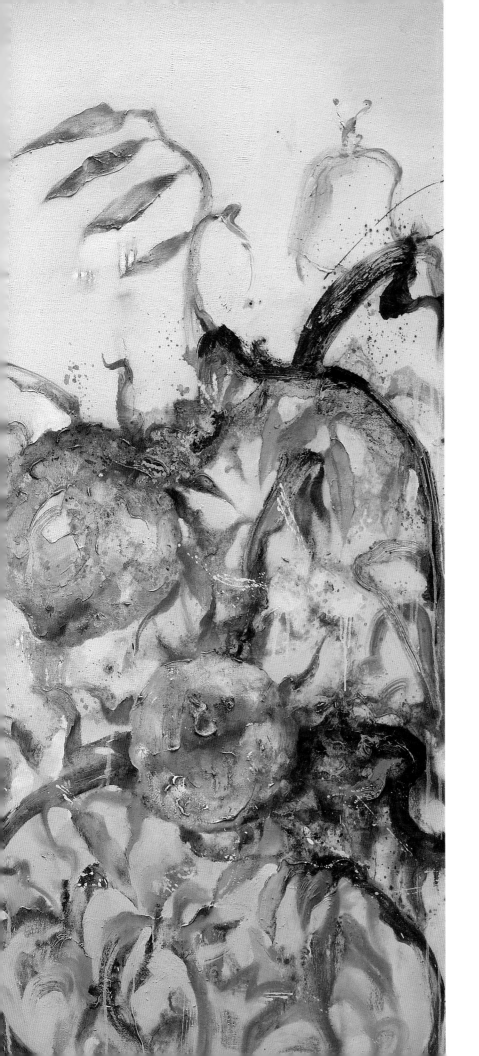

鱼的遨游，布面油画，150×180厘米，2007年
The Fish's Travel, Oil on canvas, 150×180cm, 2007

Plates

《毒物仙珍》系列
"Poisonous and Celestial Treasure" Series
2008

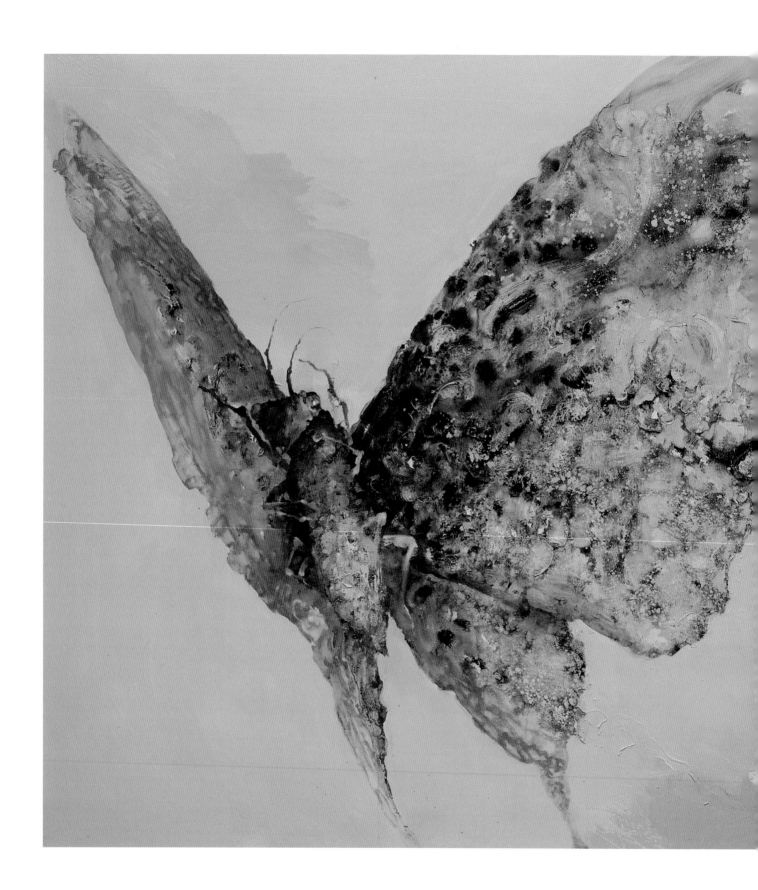

蝴蝶No.1，布面油画，160×200厘米，2008年
Butterfly No.1,Oil on canvas, 160×200cm,2008

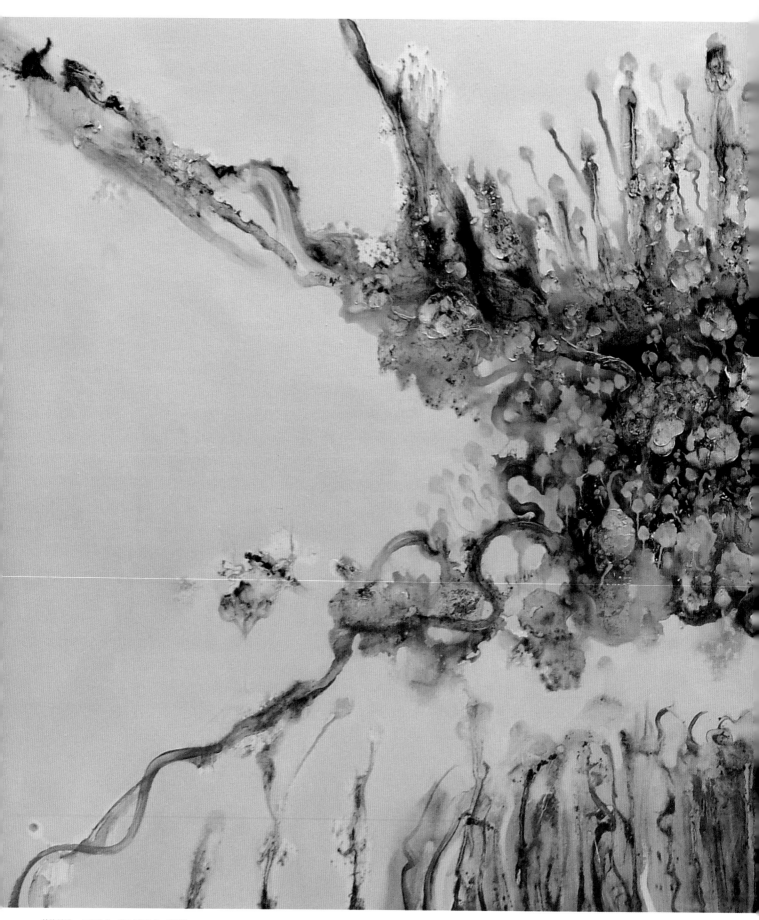

花的异境，布面油画，200×360厘米，2007年
Fantasticality of flower, Oil on canvas, 200×360cm,2007

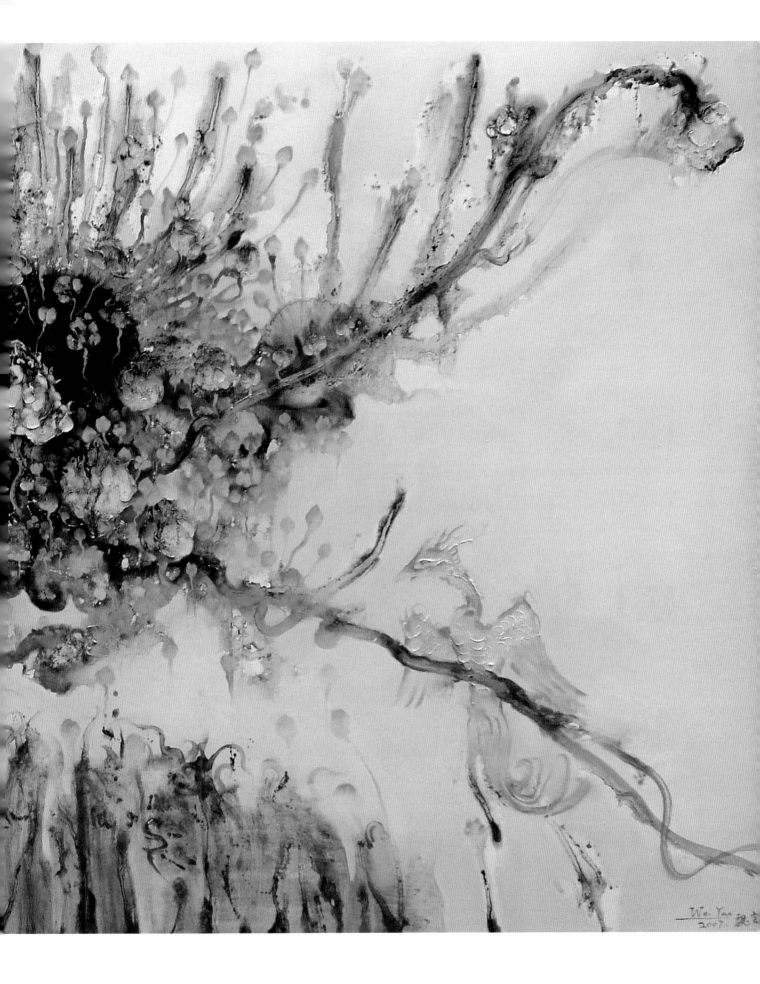

Wei Yan
2007.

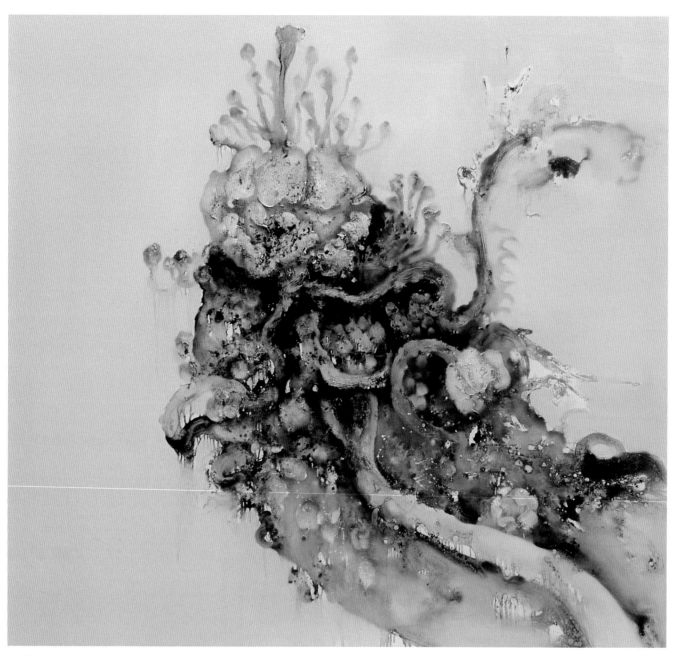

花的异境No.2，布面油画，140×150厘米，2007年
Fantasticality of flower No.2, Oil on canvas, 140×150cm, 2007

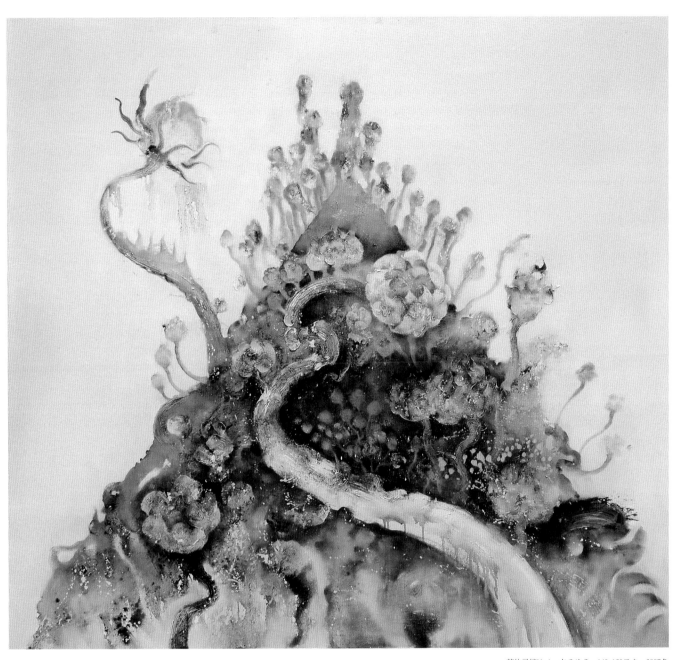

花的异境No.1，布面油画，140×150厘米，2007年
Fantasticality of Flower No.1, Oil on canvas, 140×150cm, 2007

无忧谷，布面油画，200×300厘米，2007年
The Valley Sans Souci, Oil on canvas, 200×300cm, 2007

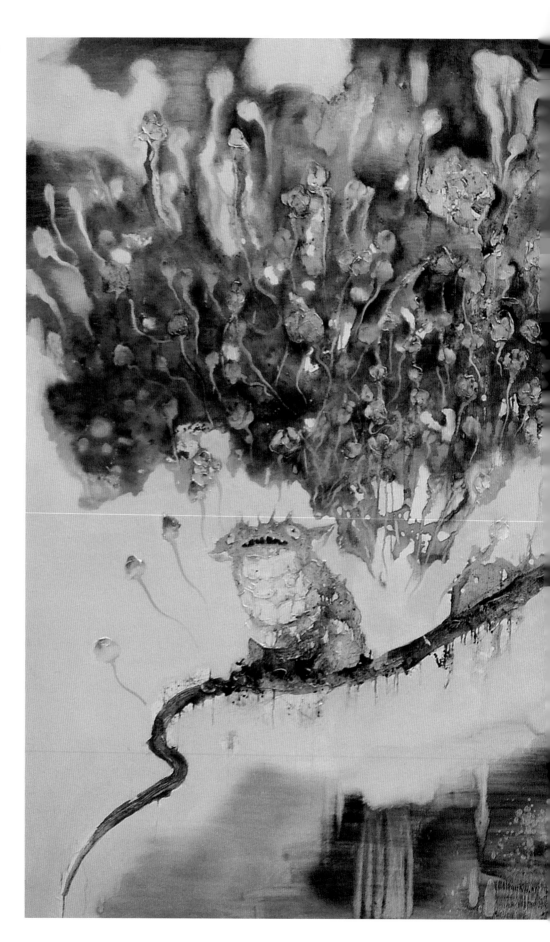

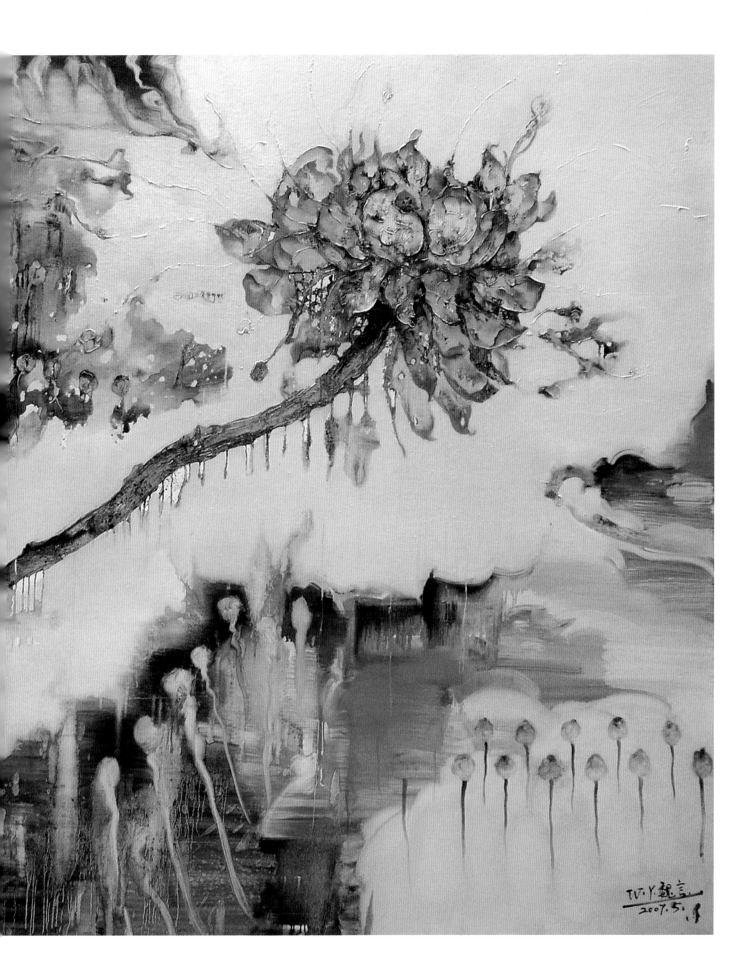

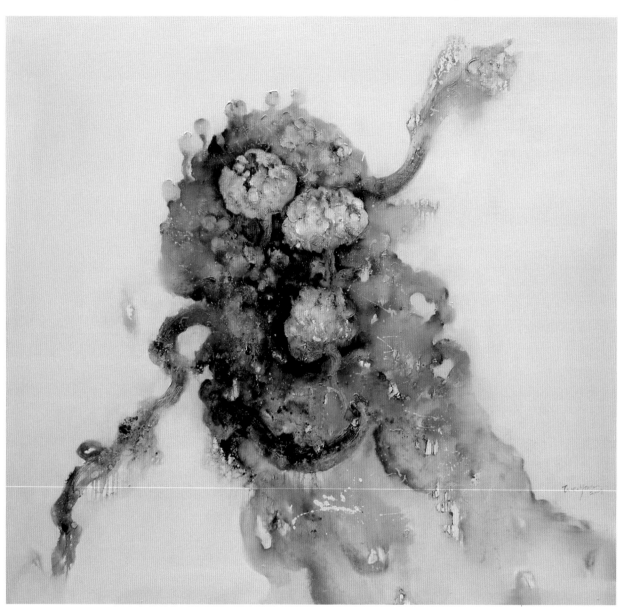

异化论No.1，布面油画，140×150厘米，2008年
*On Heterogeneity No.1,*Oil on canvas,140×150cm,2008

异化论No.5，布面油画，140×150厘米，2008年
*On Heterogeneity No.5,*Oil on canvas,140×150cm, 2008

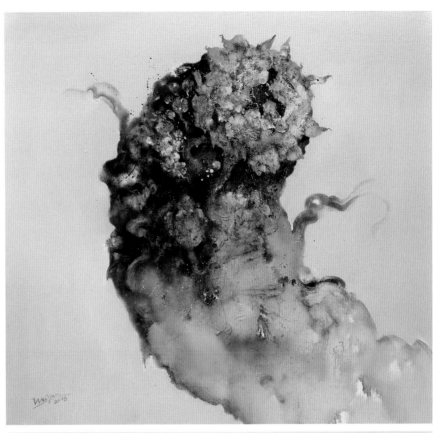

异化论No.6，布面油画，140×150厘米，2008年
*On Heterogeneity No.6,*Oil on canvas, 140×150cm, 2008

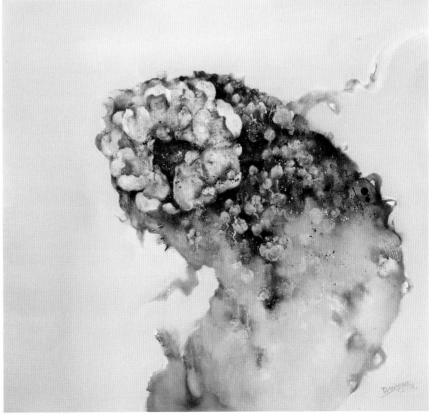

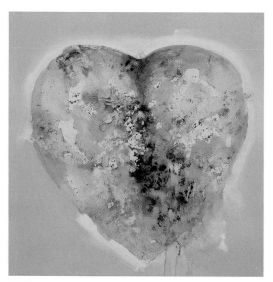

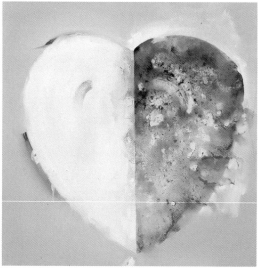

油画小稿-心学，布面油画，100×100厘米，2008年
On Mind, Oil on canvas, 100×100cm, 2008

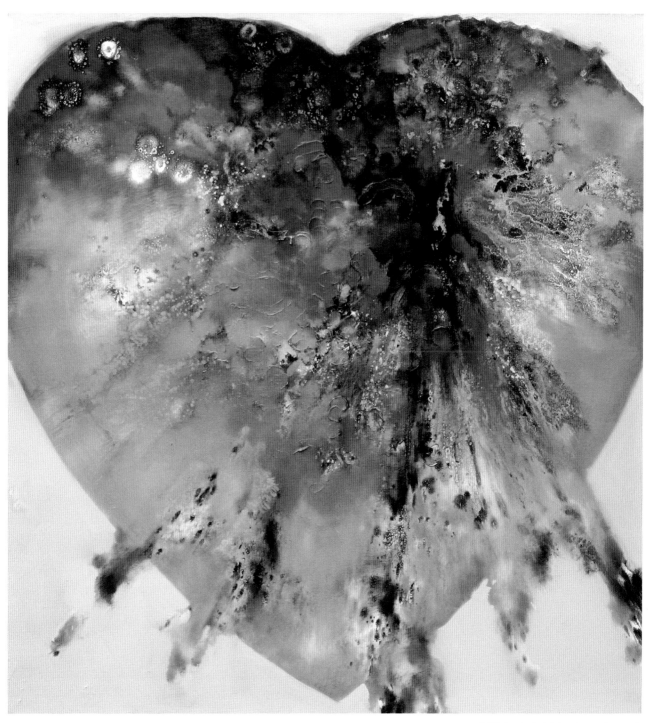

欲望的心No.3，布面油画，150×140厘米，2008年
Heart of Desire No.3, Oil on canvas, 150×140cm, 2008

造化No.1，布面油画，150×180厘米，2007年
CreatureNo.1,Oil on canvas, 150×180cm, 2007

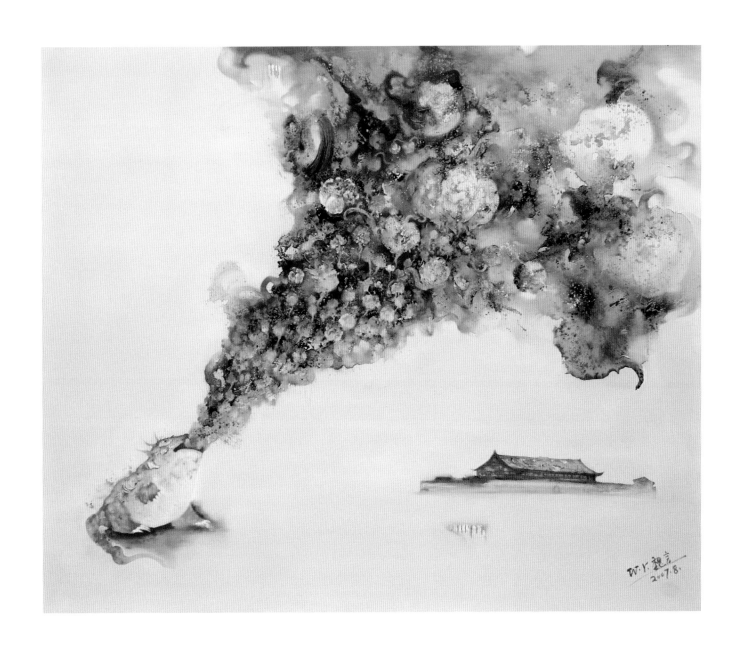

造化No.2(局部)，布面油画，250×200厘米，2008年
Creator No.2, Oil on canvas, 250×200cm, 2008

Plates

《异述》系列
"Alternative Reference" Series
2008~2009

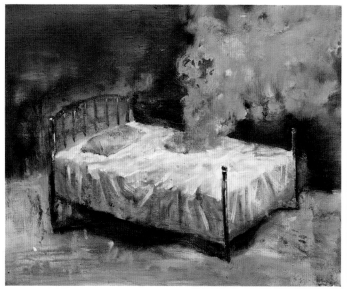

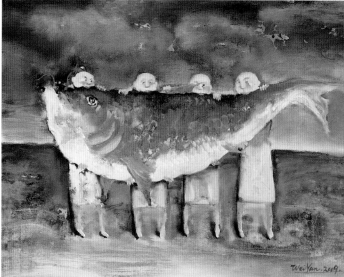

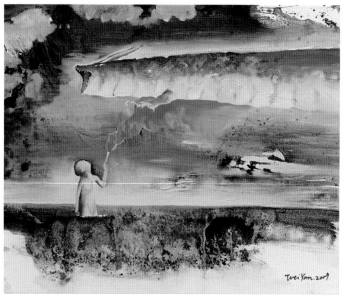

油画小稿，布面油画，40×50厘米，40×50厘米,50×60厘米，2009年
Studies, Oil on canvas, 40×50cm, 40×50cm, 50×60cm, 2009

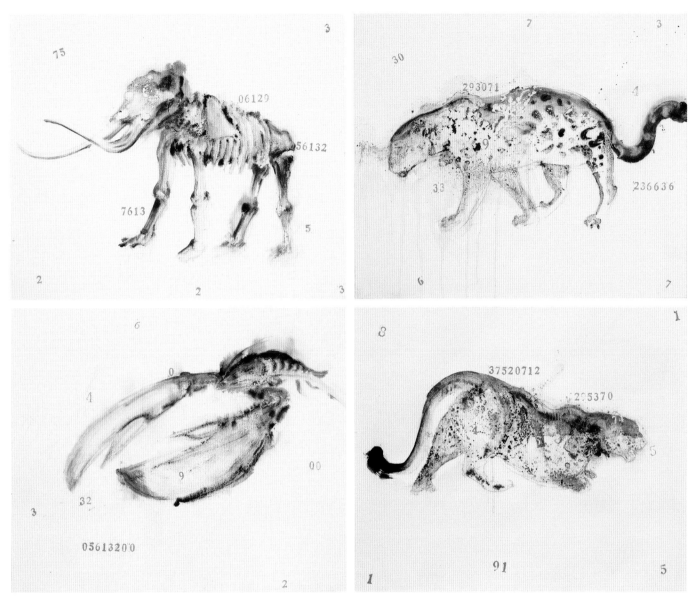

考古生物学，布面油画，40×50厘米×4幅，2009年
Archaeological biology, Oil on canvas, 40×50cm×4, 2009

梦溪笔谈，布面油画，160×200厘米，2009年
The Dream Rivulet Didry, Oil on canvas, 160×200cm, 2009

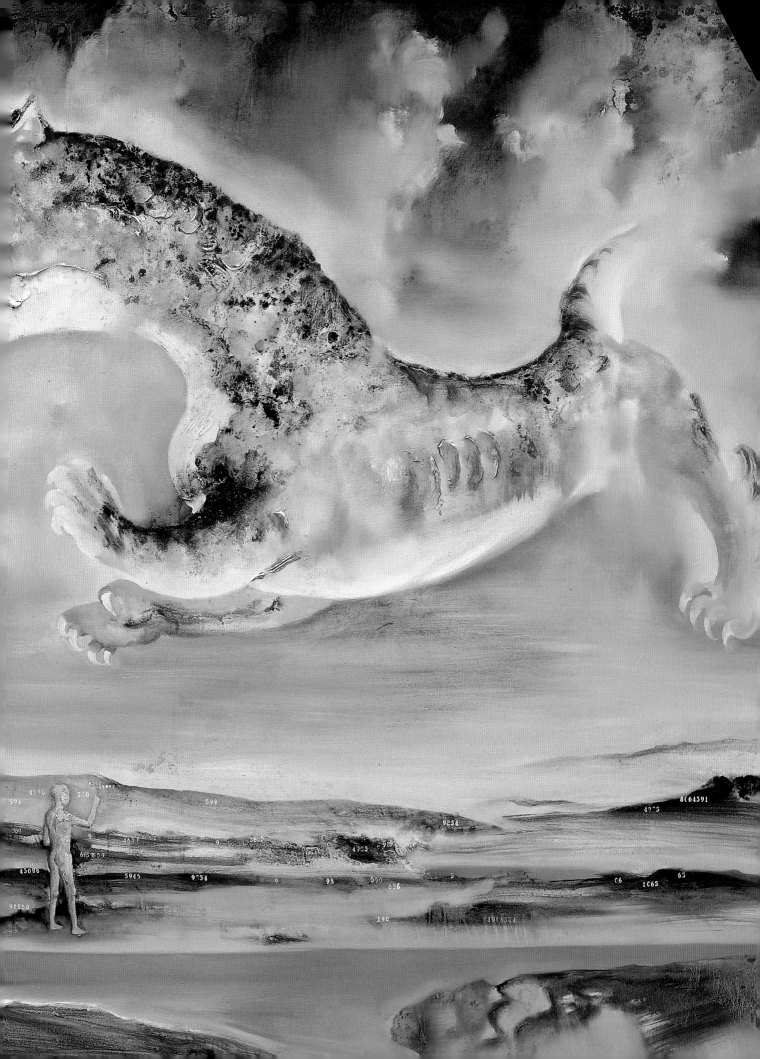

树术1号，布面油彩，140×220厘米，2009年
Wood Tactics No.1, Oil on canvas, 140×220cm, 2009

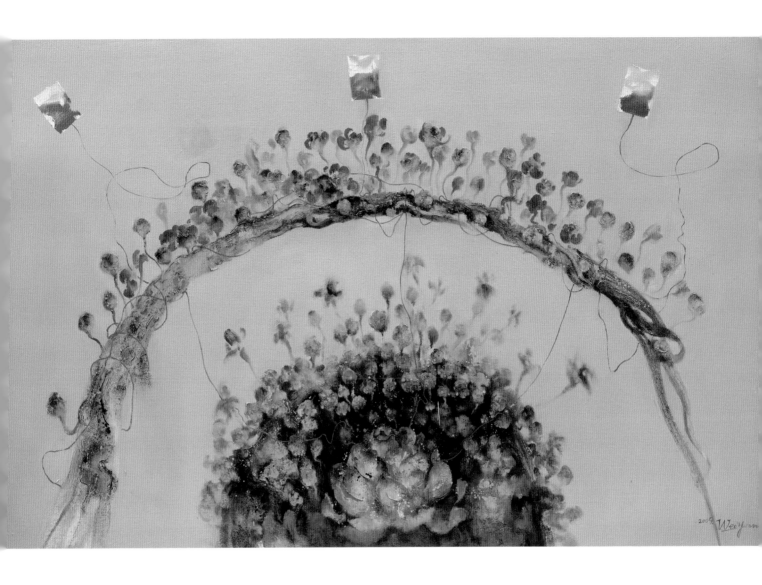

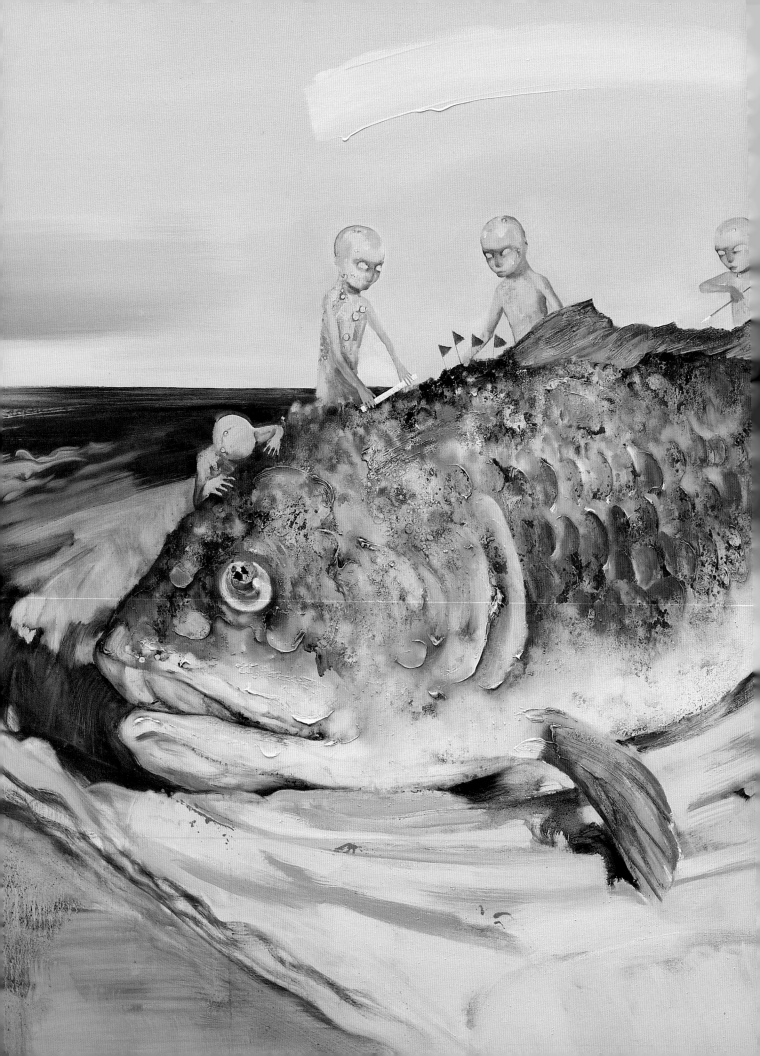

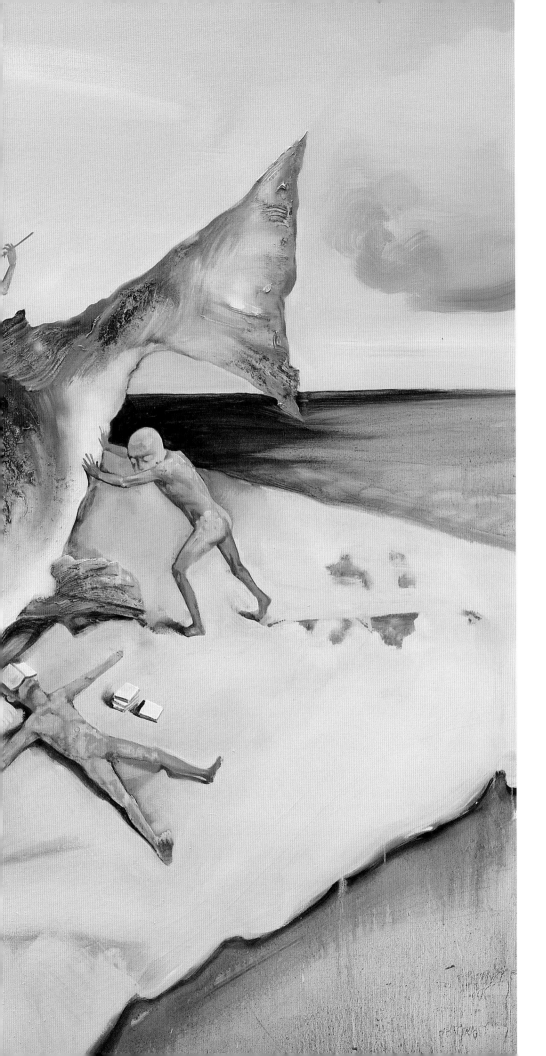

人鱼杂志，布面油彩，160×200厘米，2009年
Merman Notes, Oil on canvas. 160×200cm, 2009

食人鱼和食鱼人，布面油画，160×200厘米，2009年
Piranha and Fish eater ,Oil on canvas, 160×200cm,2009

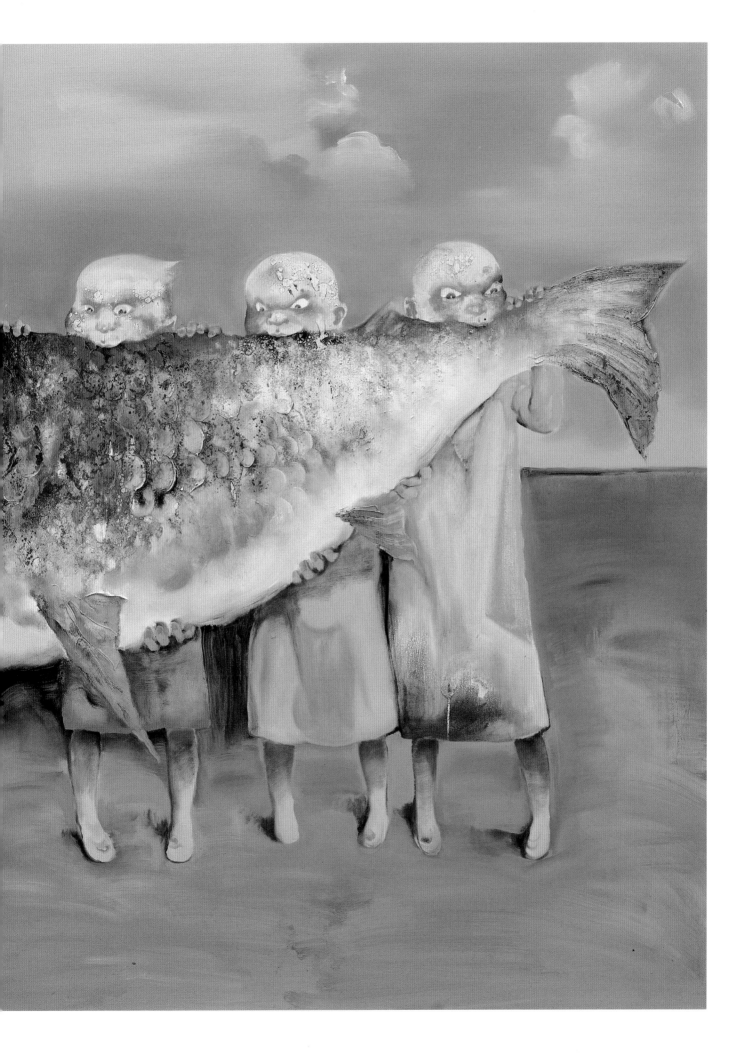

冥想3：欲望眼睛，布面油画，160×200厘米，2008年
Memory No.3- Eyes of Desire, 160×200cm, 2008

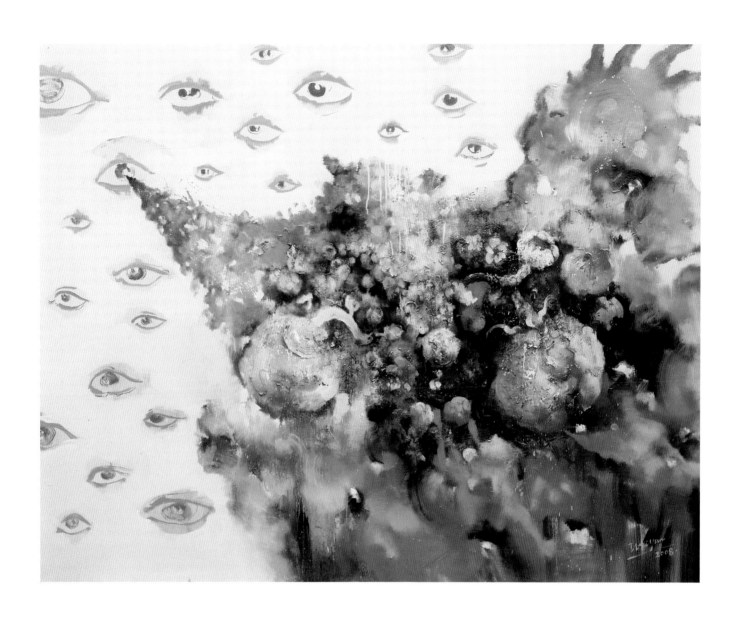

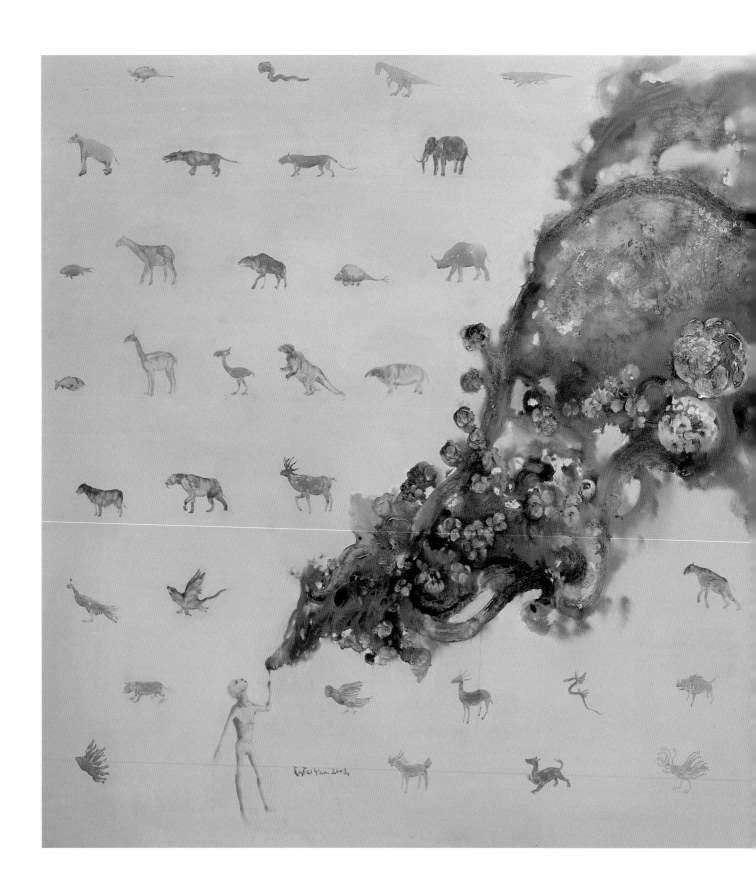

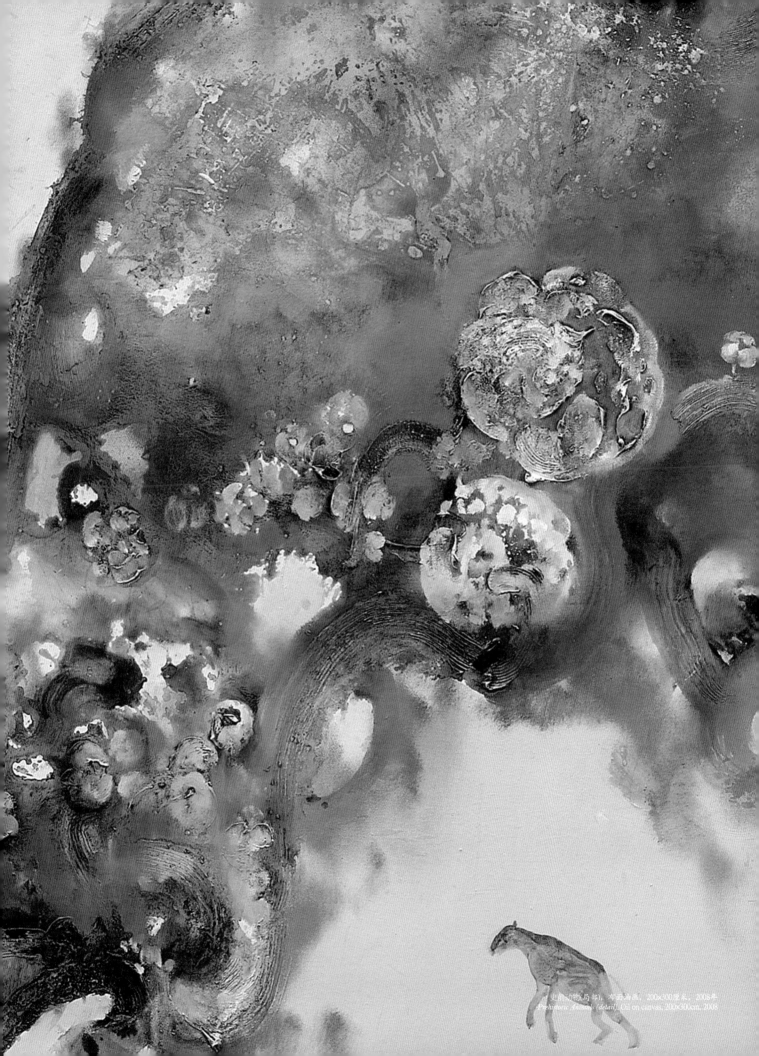

史前动物(局部)，布面油画，200×300厘米，2008年
Prehistoric Animals (detail), Oil on canvas, 200×300cm, 2008

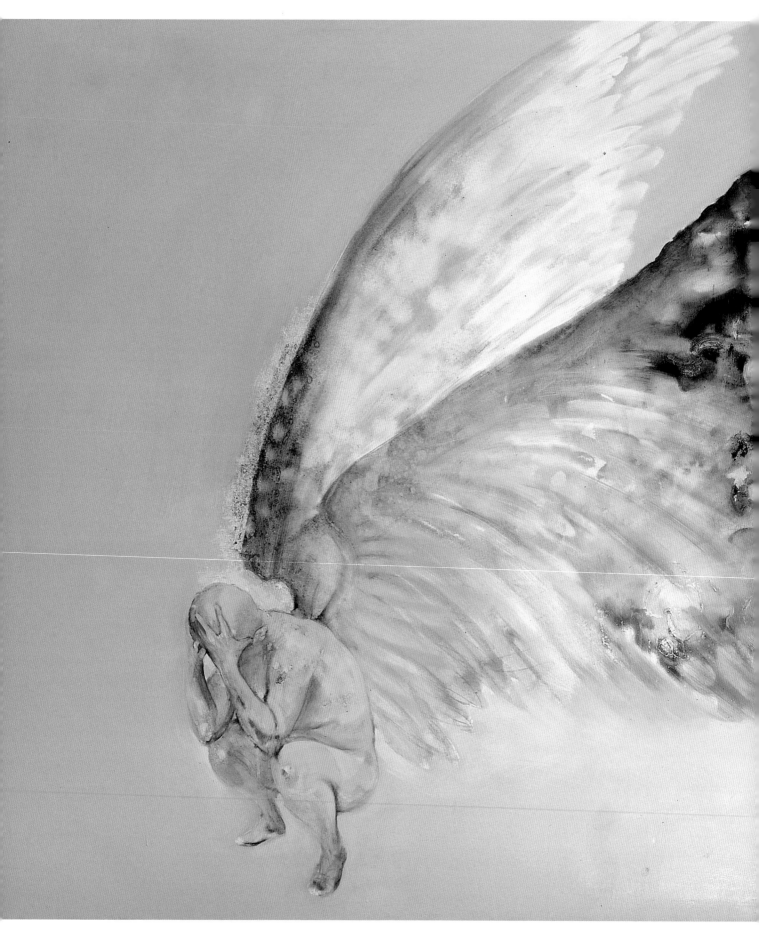

戊子年的老蒋，布面油画，200×300厘米，2008年
Laojiang in the year of Wuzi, Oil on canvas, 200×300cm , 2008

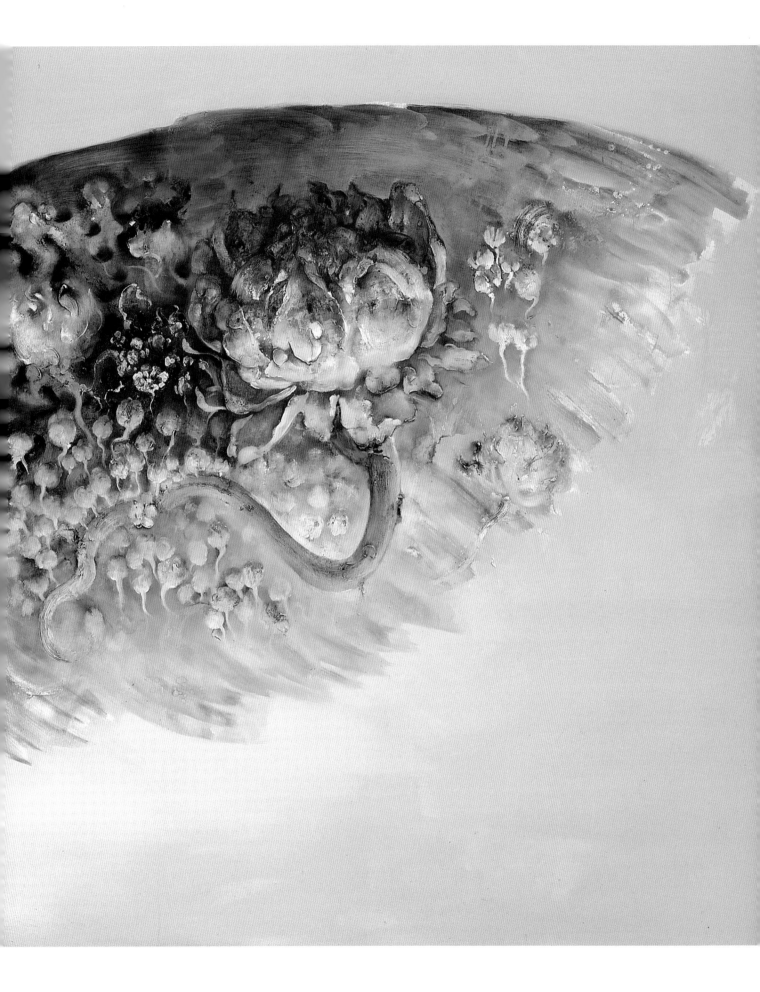

与大龙有关的33组数据，布面油画，200×250厘米，2005-2009年完成
33 sets of data related to big dragon, Oil on canvas, 200×250cm, finished in 2005-2009

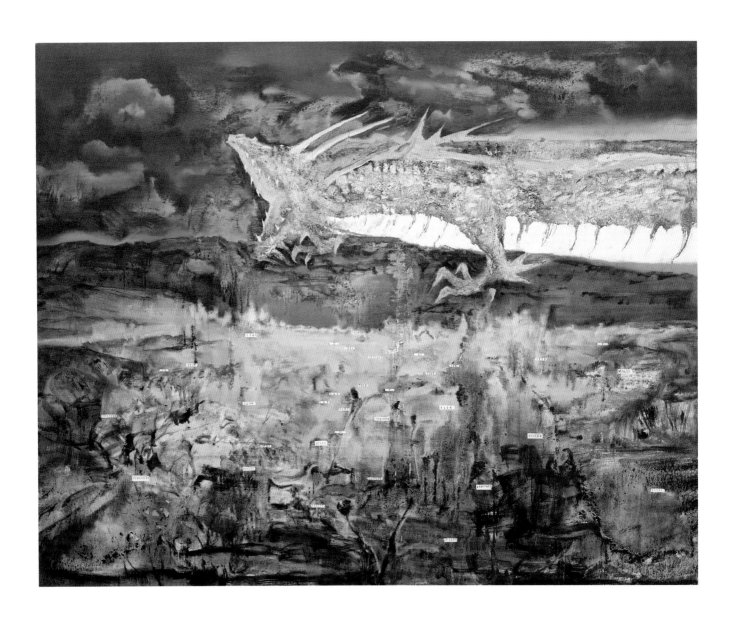

与祝融有关的62组数据，布面油画，200×250厘米，2005-2009年完成
63 sets of data related to Zhurong, Oil on canvas, 200×250cm, finished in 2005-2009

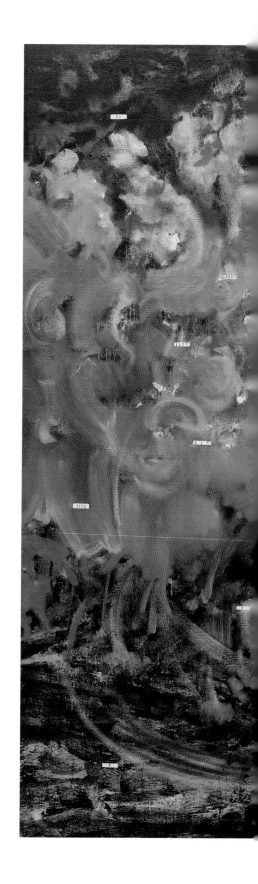

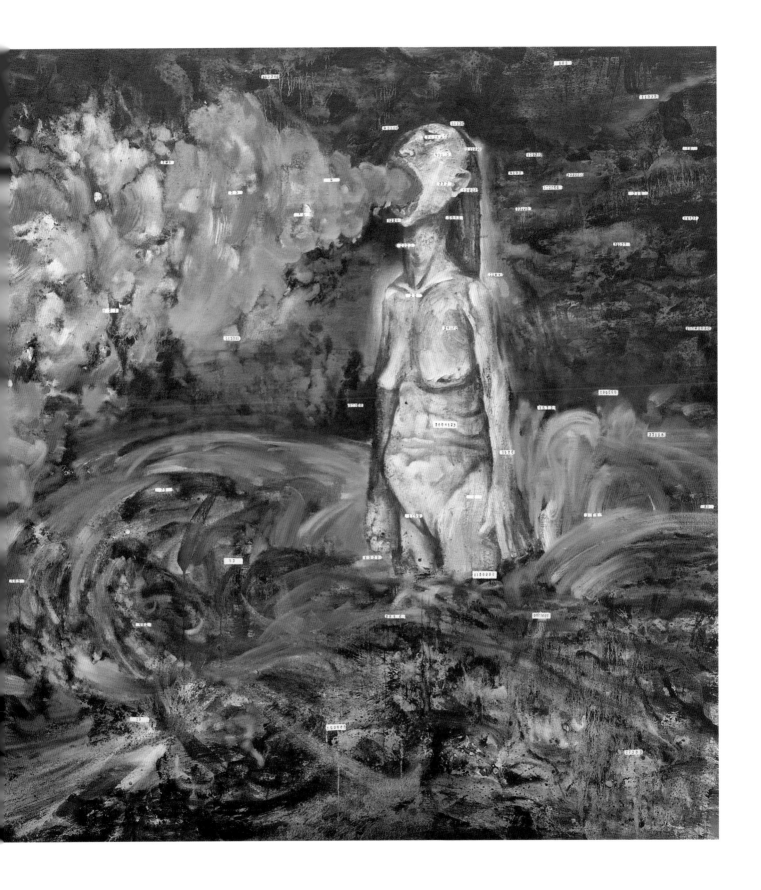

赫斯特密码，布面油画，200×200厘米，2009年
Damien Hirst, Oil on canvas, 200×200cm, 2009

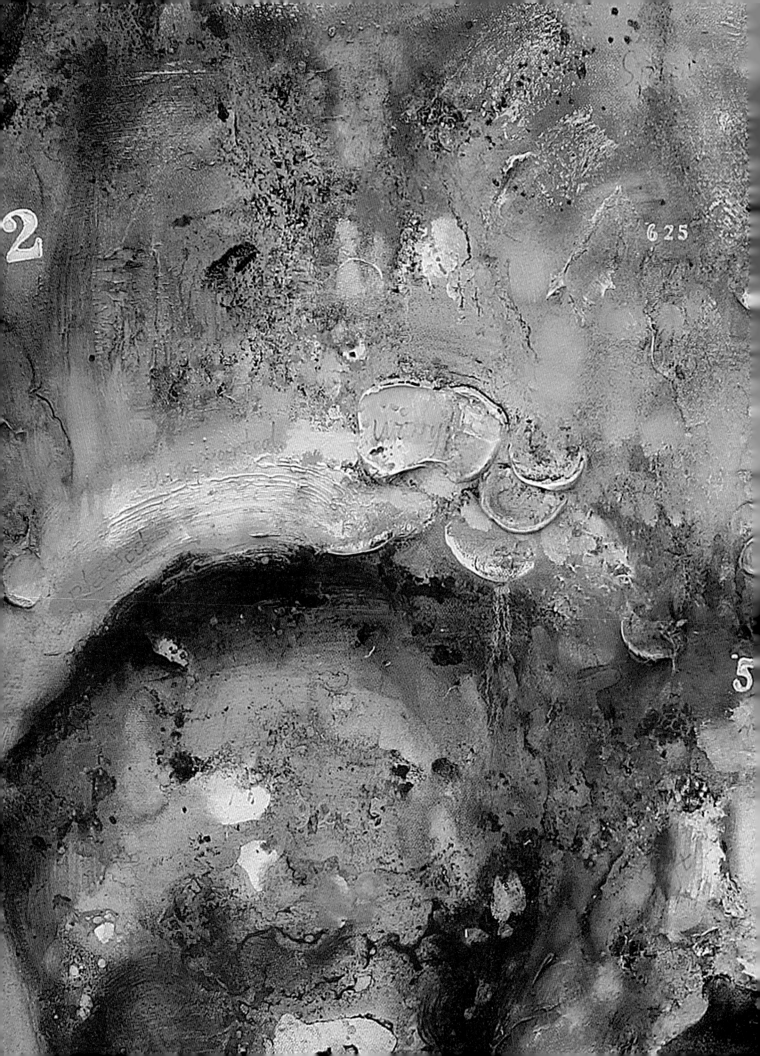

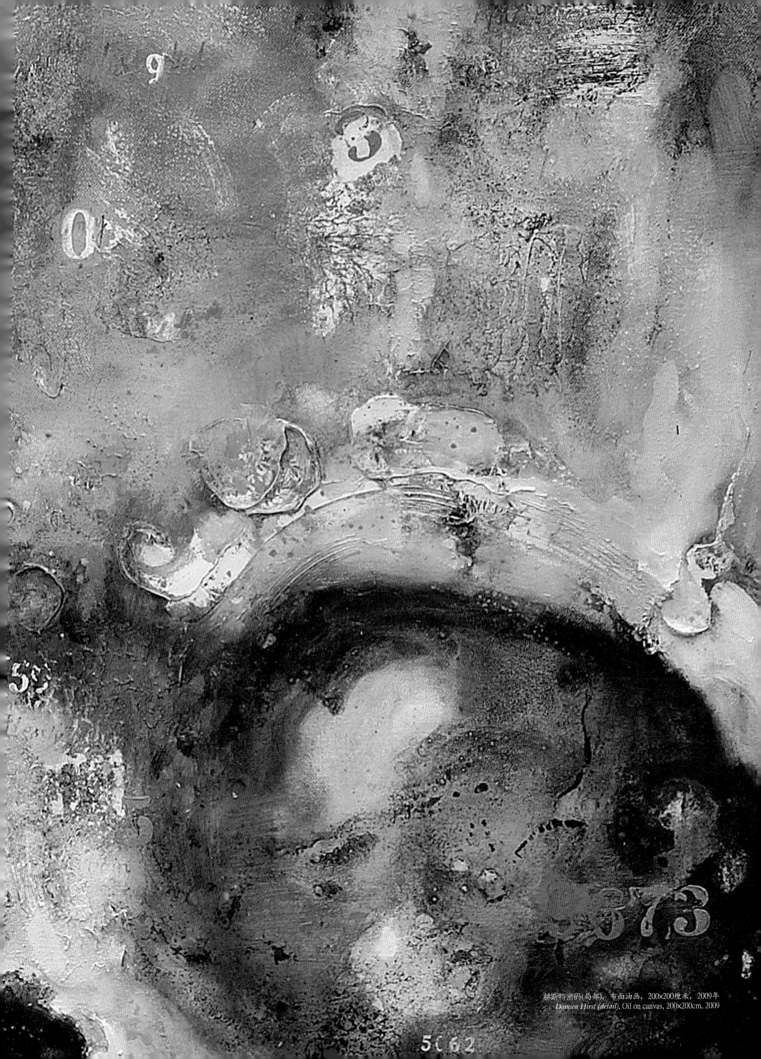

赫斯特密码(局部)，布面油画，200×200厘米，2009年
Damien Hirst (detail), Oil on canvas, 200×200cm, 2009

虫在昆仑，混合媒介，昆仑山，2007年7月18日
Lingshou in Kunlun, Mixed Media, Kunlun Mountain,18th July 2007

2007年7月18日下午15点13分
地点：昆仑山山口
海拔高度5200--5280米
温度-2摄氏度
6-8级阵风
晴
远处是可可西里无人区

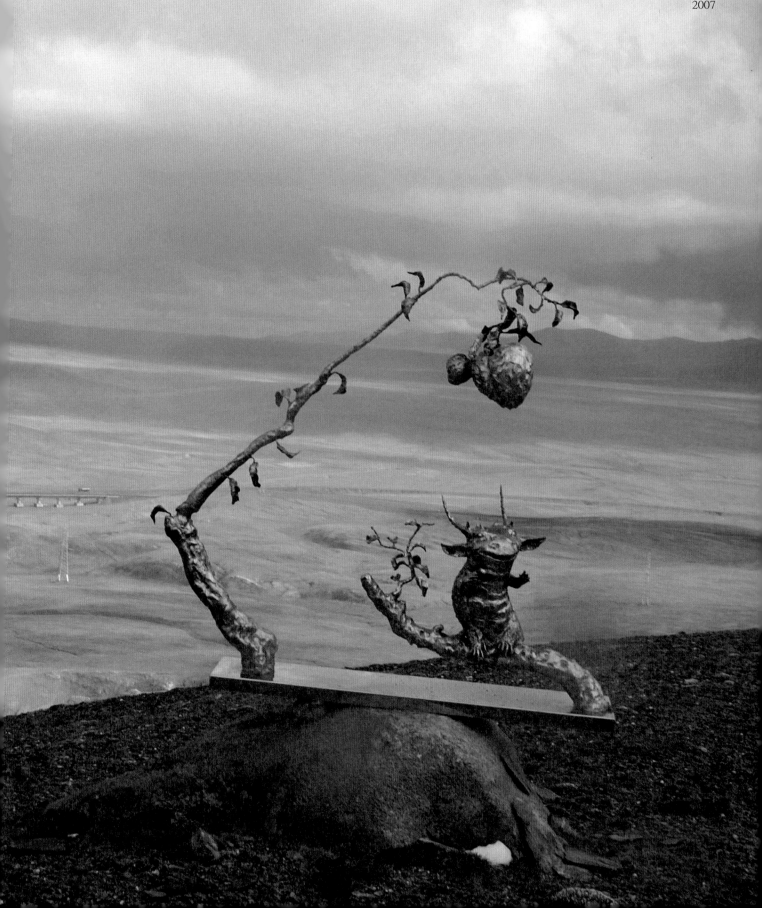

Synthesized Media Works

虫在昆仑
Lingshou in Kunlun
2007

"虫在昆仑"实施方案

一、行为过程分为三个部分：

1.现场实施：

A.运送：灵兽雕塑从成都经西宁—格尔木运输至现场（选址昆仑山。最早选定的是西王母瑶池，后因交通阻断另改为昆仑山口，海拔高度5100米处。）

B.作品拆分：工人用氧焊工具取下雕塑树上的灵兽，就地选定一处，挖2-3米的深坑，

C.埋葬：将灵兽埋藏于坑中，用土埋合，十年以后取出。

2.将卸下了剩余部分的雕塑包装运回，用于展览和相关宣传。（方案另备）

3.十年之后(2017年)将昆仑山所埋藏之后重新挖出，还原完整雕塑。（展览方案另备）

二、技术支持问题：

1.需一名技术人员（助手张全强）随同进藏，现场需使用氧焊切割设备。

2.挖掘现场需要机械操作，需租用挖掘破土设备，还需自备发电设备等。

3.雕塑总重170斤左右，其中灵兽重约30-40斤，埋土需要使用5-6名工人。

4.因时间安排在高原雨季，需要与当地气象部门取得联系，及时了解天气及气候情况。

5.即时通讯设备：对讲机、手机

6.记录设备：除影像记录外需要专人记录行程、天气、时间、地点、过程。

7.因实施作品的选址地形复杂，多为越野路，时逢雨季，勘察路况和实施作品，需要联系当地专业越野车和牵引车，与当地林业部门联系。

三、文献记录包含：

1.跟踪采访的影像记录。

2.实施过程的文字记录。

3.创作手记。

补充材料：

团队一共9人，主要成员名单如下：

助手：张全强，川音成都美术学院雕塑系

技术支持：喻君，原弓艺术机构，现为中环艺术基金会顾问。

摄影师：杨海波，中央电视台编导

助理摄影：杨佳，中央电视台编导

随行人员：中央美术学院的古笃巴朵（张逸），他当时负责实施他的导师吕胜中的作品。

西宁热气球公司的员工等等。

整个艺术计划的实施经费由上海原弓美术馆提供。

2009年5月4日
整理于北村独立工场

The Implementation Plan of "Lingshou in Kunlun"

I. The course of performance has three parts:

1. Site implementation:

A. Delivery: The Lingshou sculpture is transported to the site from Chengdu to the site via Xining-Golmud. (The site is the Kunlun Mountain. First selection is Xiwangmuyaochi, but because of the traffic blocking it is changed into the Kunlun Mountain whose altitude is of 5100 meters.

B. Taking Apart the Work: The works removed the Lingshou from the sculpture tree by oxygen-welding tool, selected a spot and dug a pit 2-3m deep.

C. Burial: Buried in the pit, covering with soil, the Lingshou is waiting to be taken out after 10 years.

2. The remainder of the sculpture is packed and delivered back for the use of exhibition and the related publicity. (The plan will be prepared separately.)

3. Ten years later, in 2017, the buried in the Kunlun Mountain will be excavated out to restore the integrity of the sculpture. (The plan will be prepared separately.)

II. Technical Support:

1.A technical staff (assistant Zhang Quanqiang) is required to accompany to enter into Tibet. The site requires the oxygen-welding-cutting equipment.

2.Excavation needs machine. The equipment of excavation should be borrowed. The power equipment is also required.

3.The weight of the sculpture is about 85kg and the Lingshou weighs about 15-20kg, so the process of burial needs 5-6 workers.

4.Because the scheduled time is during the rainy season of plateau, it is required to contact with the local meteorological department to keep abreast of the weather and climatic conditions.

5.The instant communication equipment is required, such as walkie-talkie and cell phones.

6.Recording equipment: in addition to video recording, a person is required to record the itinerary, weather, time, place and process.

7.Because the terrain is very complex and mostly of off- road, and it is of rainy season, it's required to contact the local professional off-road vehicles and tractors and the local forestry department to investigate the road condition and implement the work.

III. The literature records include:

1.the video records of the tracking interviews;

2.the text records of the implementation process;

3.the notes of the creation

Supplementary Materials:

The team has 9 members; the key members are as follows:

Assistant: Zhang Quanqiang, of the Sculpture Department of Chuanyin Academy of Fine Arts, Chengdu.

Technical Support: Yu Jun, of the Yuangong Art Institution, now the consultant of the Central Arts Foundation.

Photographer: Yang Haibo, director of China Central Television

Assistant Photographer: Yang Jia, director of China Central Television

Entourage: Zhang Yi, of the Central Academy of Fine Arts (he was responsible for the implementation of his mentor Lv Shengzhong's works) and the employees of the Xining Hot-air Balloon Company. Etc.

The implementation of the plan is funded by the Shanghai Yuangong Art Museum.

May 4, 2009
North Village Independent Workshop, Chengdu

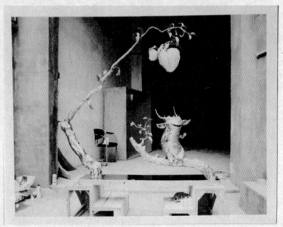

Linshou in Kunlun

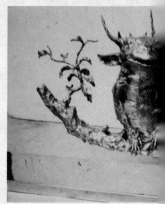

Linshou in kunlun

中国汉字里出现
"虫" 最多心偏旁部首
虫在中国人心原始
心认识有着一种方法
心宇宙轮行意义.

从05年至今,我考察了许多民间美术例如:剪纸,泥塑,面花,皮影,瓦当,
青花瓷器,木雕.在其中灵兽心构思逐渐成熟起来.书属于心情悲牛的私偶怪
的审美范畴.是一种神话心精神改车.深沉,野远,朴素灵活.天真
无邪心中含有一丝狰狞.我寻找这样一种生都自觉的无限糊糊含义.虚
神凝视着一个很古老心原始世界.

灵兽,或"虫",其能指,
代沁迩.而中国远古的智
关,例如:"虫叶咙罗"与
"谶纬"术有关.秦汉时
方才编造了预示凶心路
种刿刳古诗者中比较
由虫"心神讨学而神话是

2007. 7. 10 拍于雕塑厂.

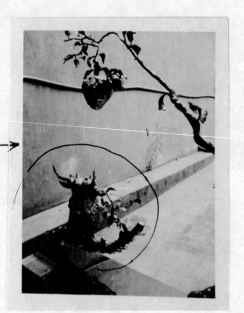

虫在昆仑,实施方案,相片、文本,2007年6月,成都
Performance plan, Photograph, Text, Paper, June 2007, Chengdu

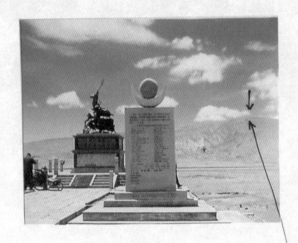

整件雕塑中被埋在
山顶的足部分. 虫的隐喻
和"树"的游世.

树和果子 现在

虫 过去 未来

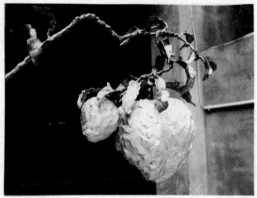

分心又
水其有
游
型师
而自
找引种
深入

虫和果子构成一组
关于生存关系的神话原型.
其果子也是植物欲望的表征.

谶纬术的内在核心

虫: 过去. 未来, 做为虫隐喻的部分.

树和果: 现在. 现存的游世. 欲望
的现实层面."

"灵兽"
虫的栖居地.

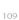

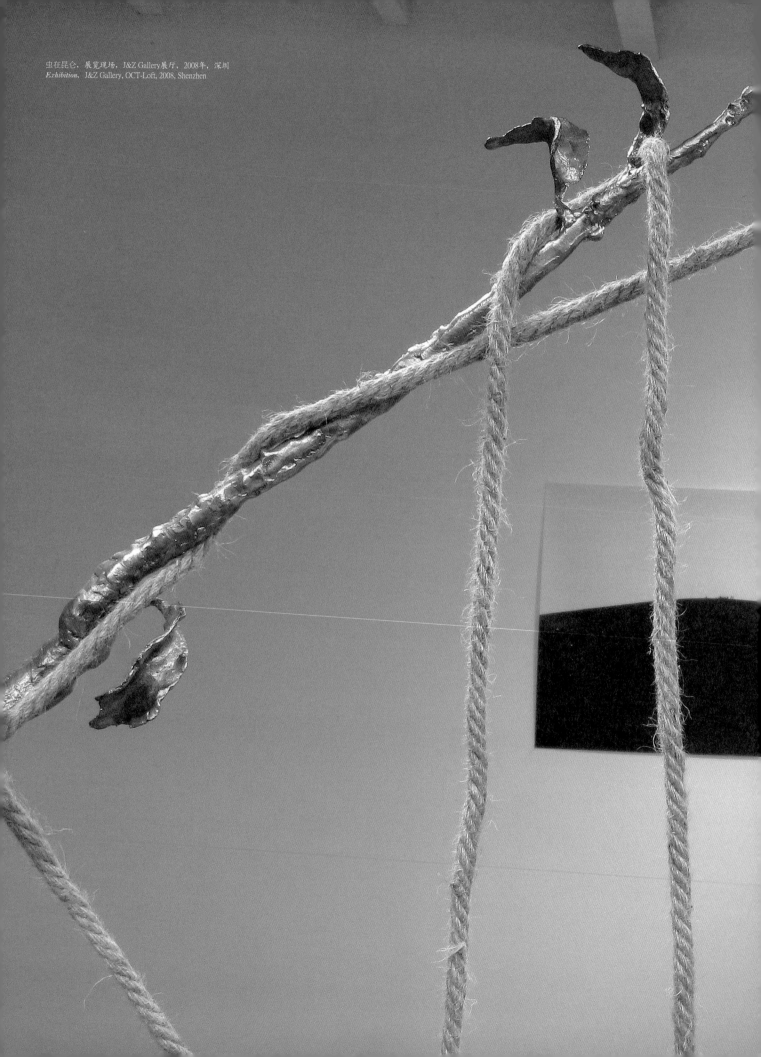

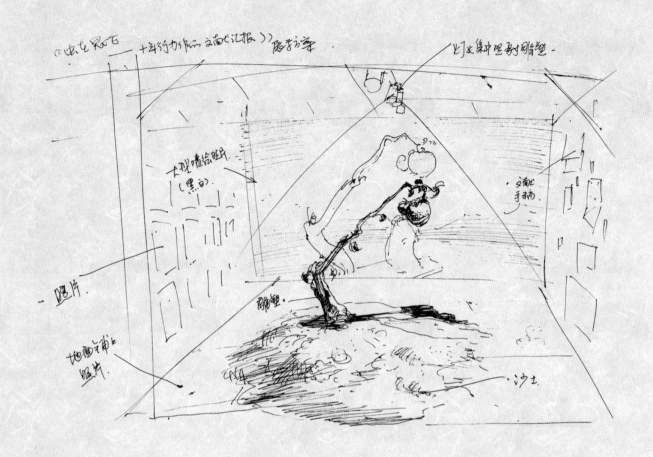

●—— 左面墙上规则挂放行为记录照片 和一篇作者文章简介

●—— 右面墙上随意挂放手稿、文献、地图、随笔、手写纸片等

●—— 地面铺上黑白手引昆仑山地貌黑白照片：
雕塑安置以地面铺上30～40cm高以沙土

●—— 背景墙挂整幅喷绘照片

扁幅要求：①照明光线强烈、充分。②布展时要考虑到周围作品以恰当
配合

②
本作品要子注重位此一种文献气围

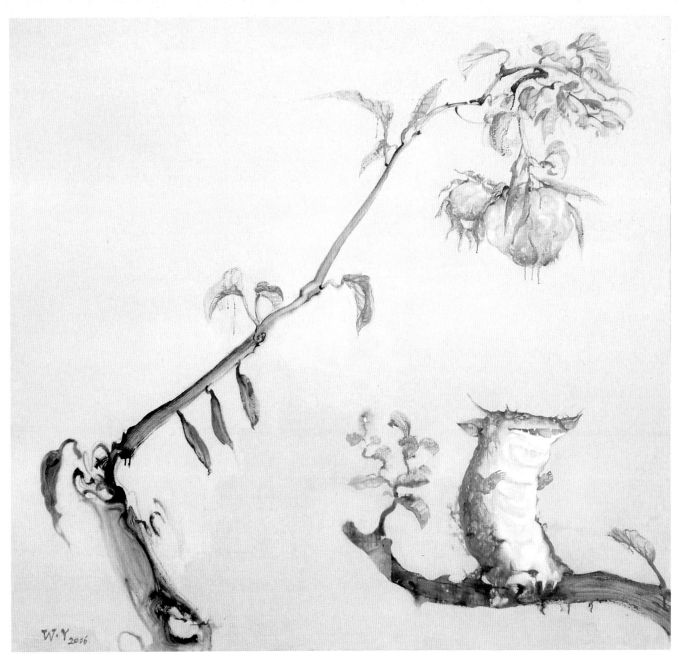

虫与果—为雕塑而作的油画稿，布面油画，140×150厘米，2008年
Lingshou and Fruits-Oil Painting for Sculpture, Oil on canvas, 140×150cm, 2008

灵兽，中国传统民间~~神兽~~神话动物，在西方文中找不到准确的词。
只有直译为"Linshou"或 Mystic Creature，而音译"Lish
做为神话的能指，承托神秘、超越、无我、灵性的目

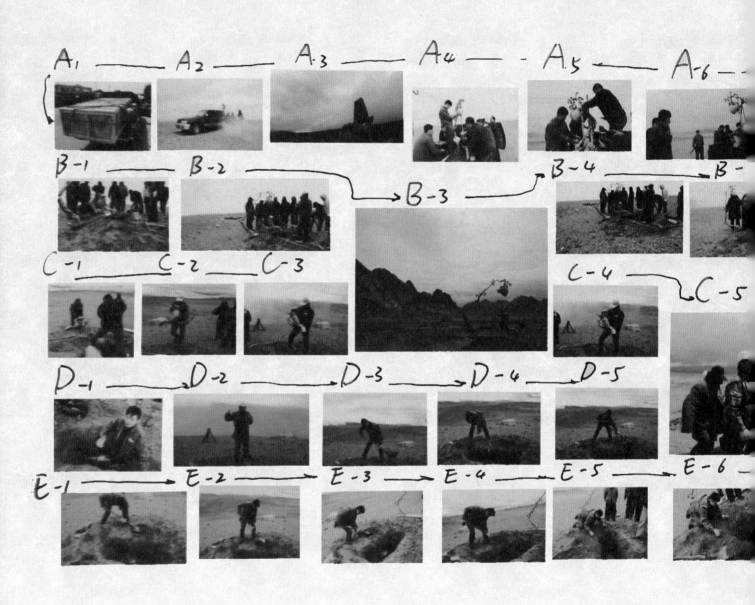

A-1 → A-2 → A-3 → A-4 — A-5 ← A-6 —

B-1 → B-2 → B-3 → B-4 → B-

C-1 — C-2 — C-3 C-4 ← C-5

D-1 → D-2 → D-3 → D-4 → D-5

E-1 → E-2 → E-3 → E-4 — E-5 — E-6

。按顺序排列，黑白照片46幅，彩色

根气念.

似乎更为狂弹地. 同样.

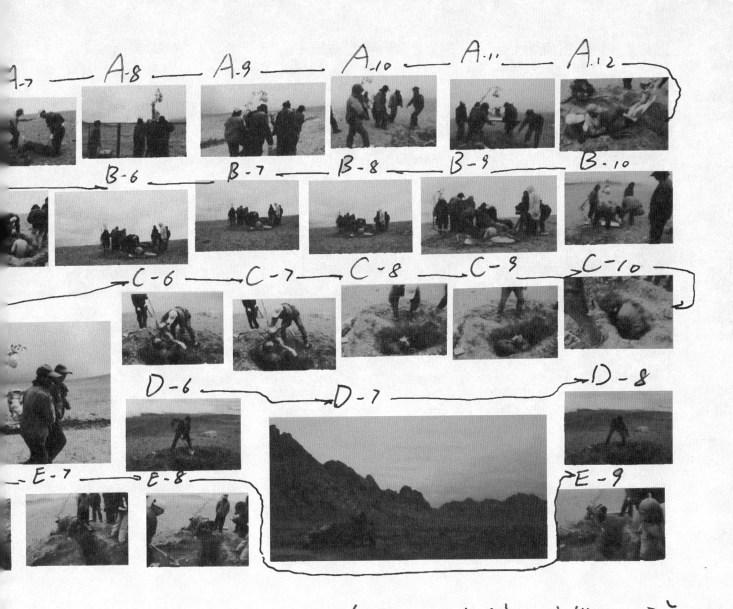

A-7 — A-8 — A-9 — A-10 — A-11 — A-12

B-6 — B-7 — B-8 — B-9 — B-10

C-6 — C-7 — C-8 — C-9 — C-10

D-6 — D-7 — D-8

E-7 — E-8 — E-9

三片动画. 共.49幅.

2007年 7月18日上午9点30出发 → 下午16:00
地点: 沿108国道进入昆仑山. 经格尔木河
神泉纳赤台、西大滩、到此昆仑山口.
海拔3500 — 4767m.
温诺: 山底 8-11C°. 山腰0 — 4℃
山口 -2 °C. 冰雨. 大风.

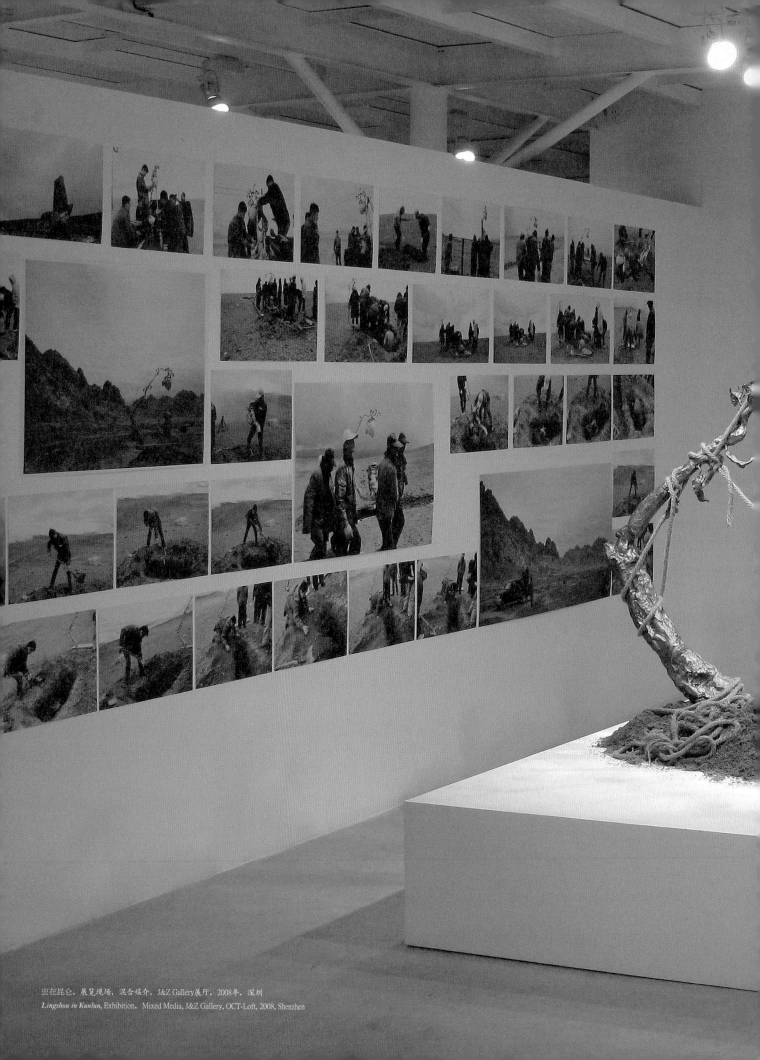

虫在昆仑，展览现场，混合媒介，J&Z Gallery展厅，2008年，深圳
Lingshou in Kunlun, Exhibition，Mixed Media，J&Z Gallery, OCT-Loft, 2008, Shenzhen

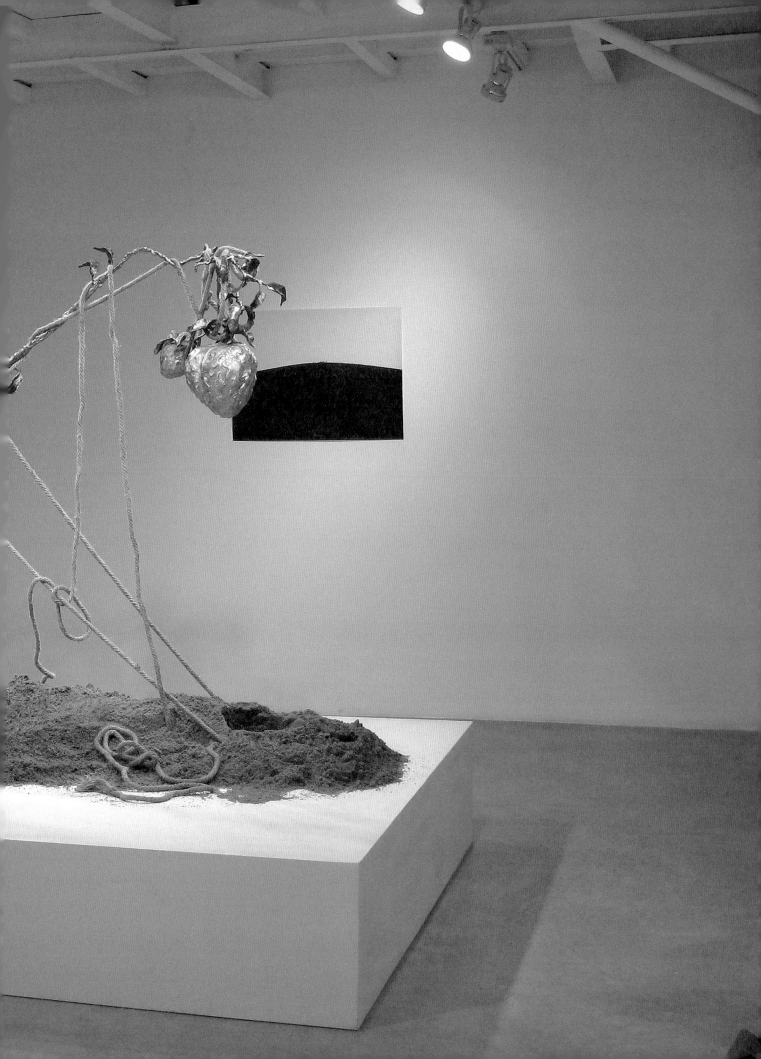

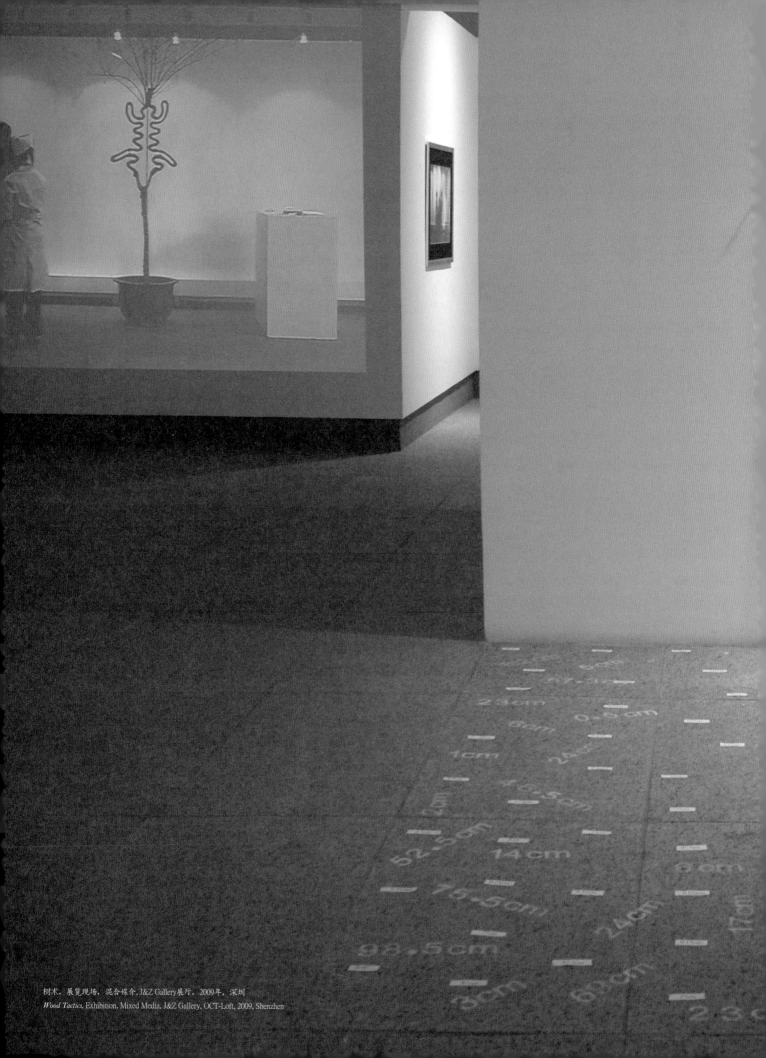

树木，展览现场，混合媒介，J&Z Gallery展厅，2009年，深圳
Wood Tactics, Exhibition, Mixed Media, J&Z Gallery, OCT-Loft, 2009, Shenzhen

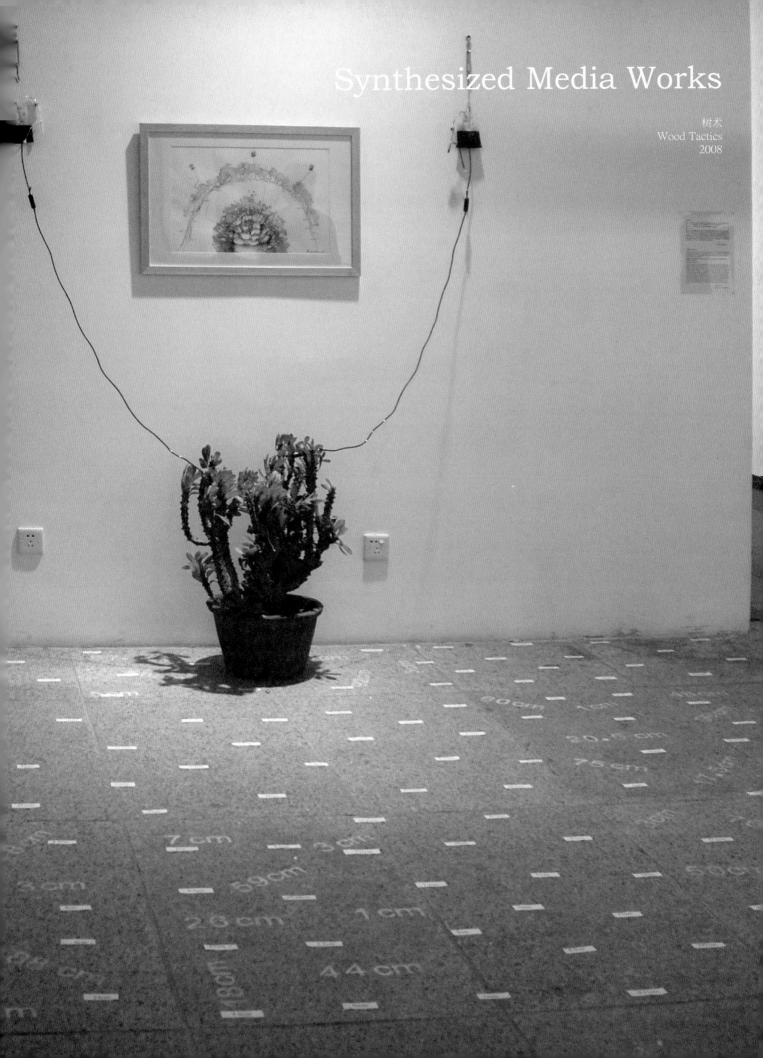

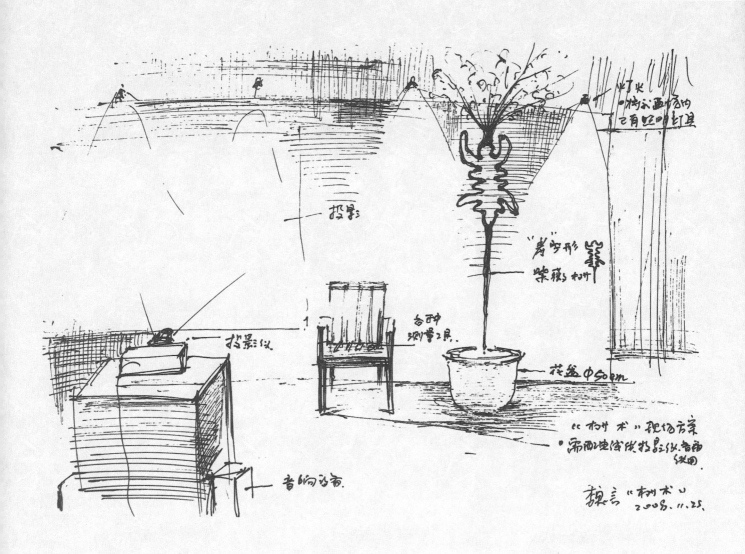

树术，为个展准备的展览方案，2009年
Wood Tactics, Exhibition Plan Text for solo Exhibition, 2009

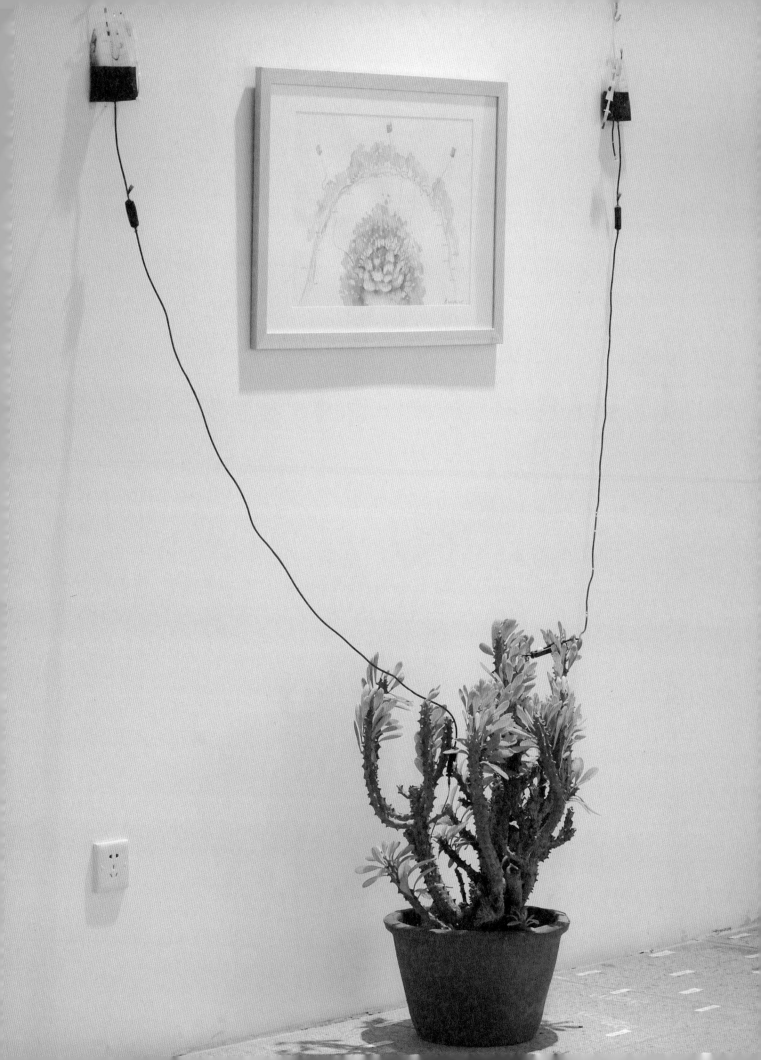

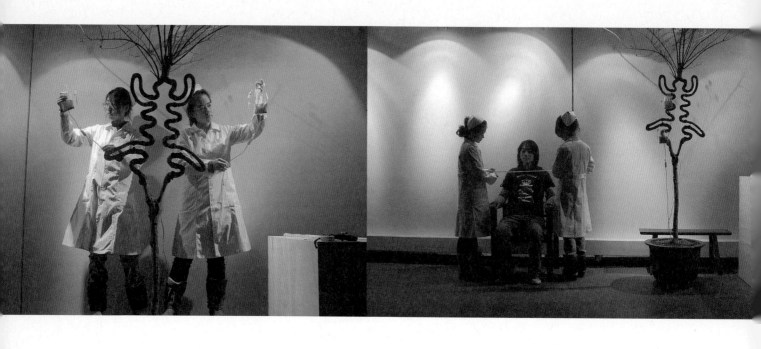

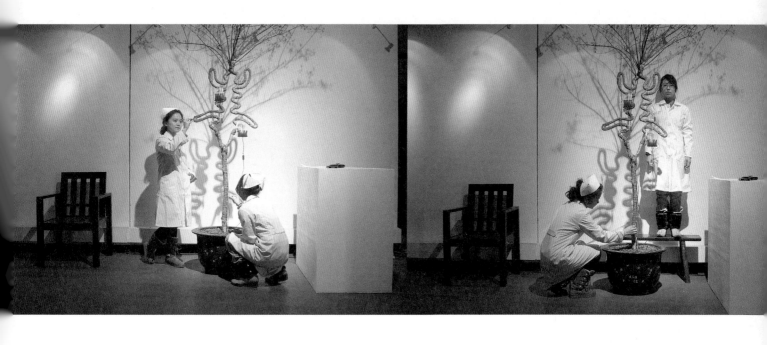

树术，观念摄影，彩色照片，60×80厘米，2008
Wood Tactics, Color photography, 60×80cm, 2008

树木，观念摄影，彩色照片，80×60厘米，2008年
Wood Tactics, Color photography, 80×60cm, 2008

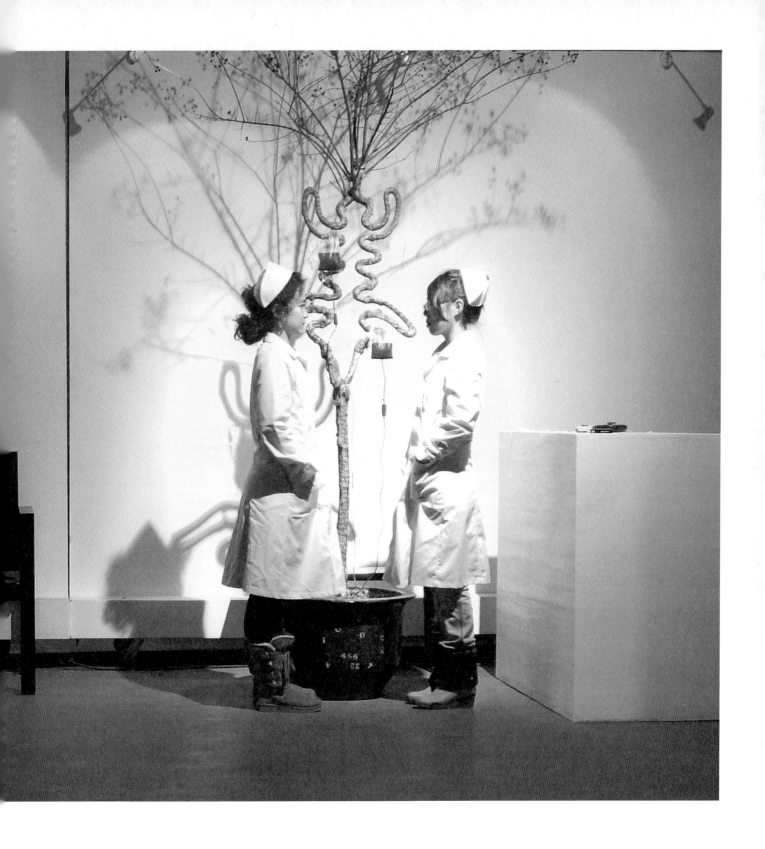

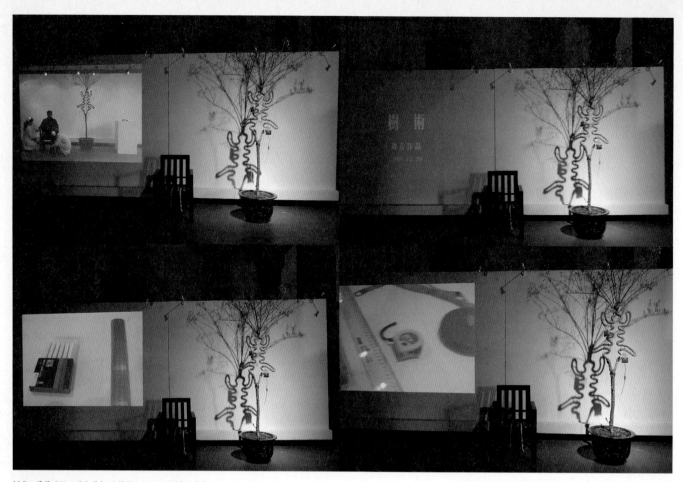

树术，展览现场，混合媒介，北村独立工场，2008年，成都
Wood Tactics, Exhibition, Mixed Media, North Village Independent Workshop, 2008, Chengdu

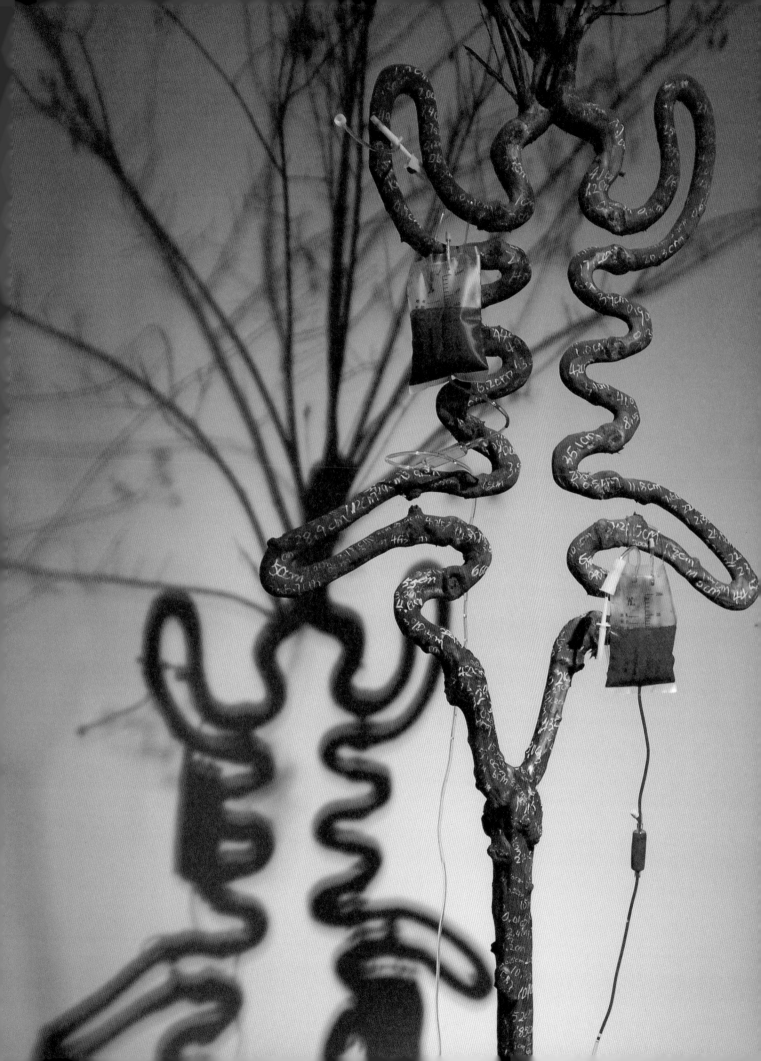

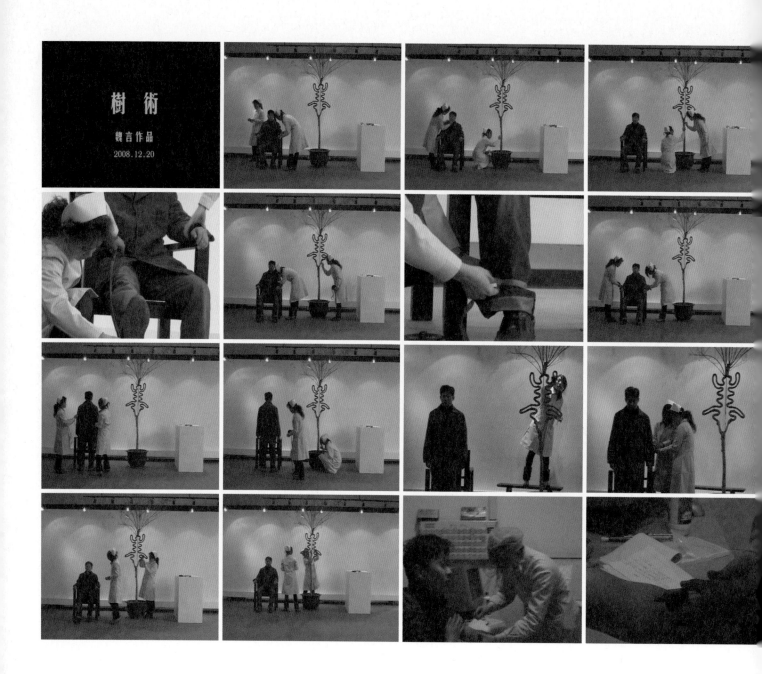

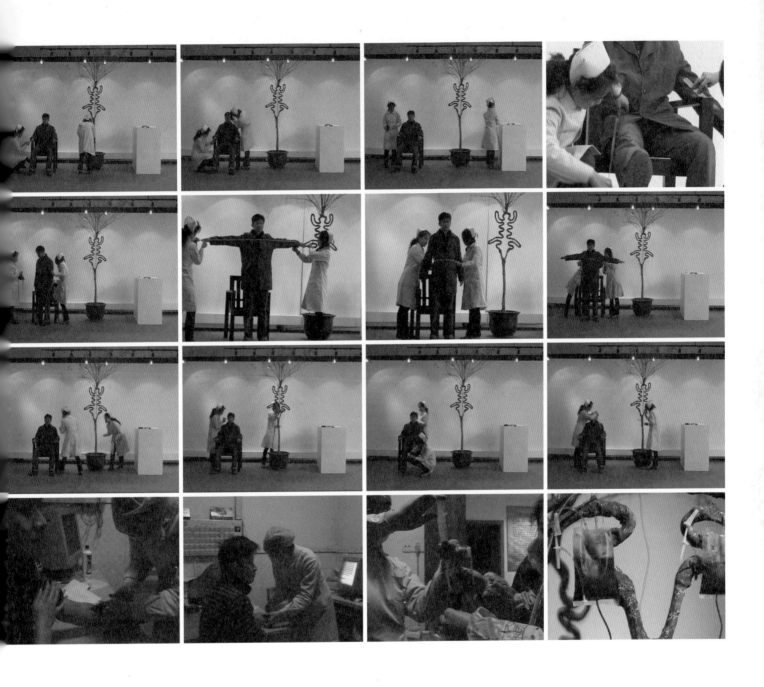

树术，影像，25分钟，北村独立工场，2008，成都
Wood Tactics, Video, 25mins, North Village Independent Workshop, 2008, Chengdu

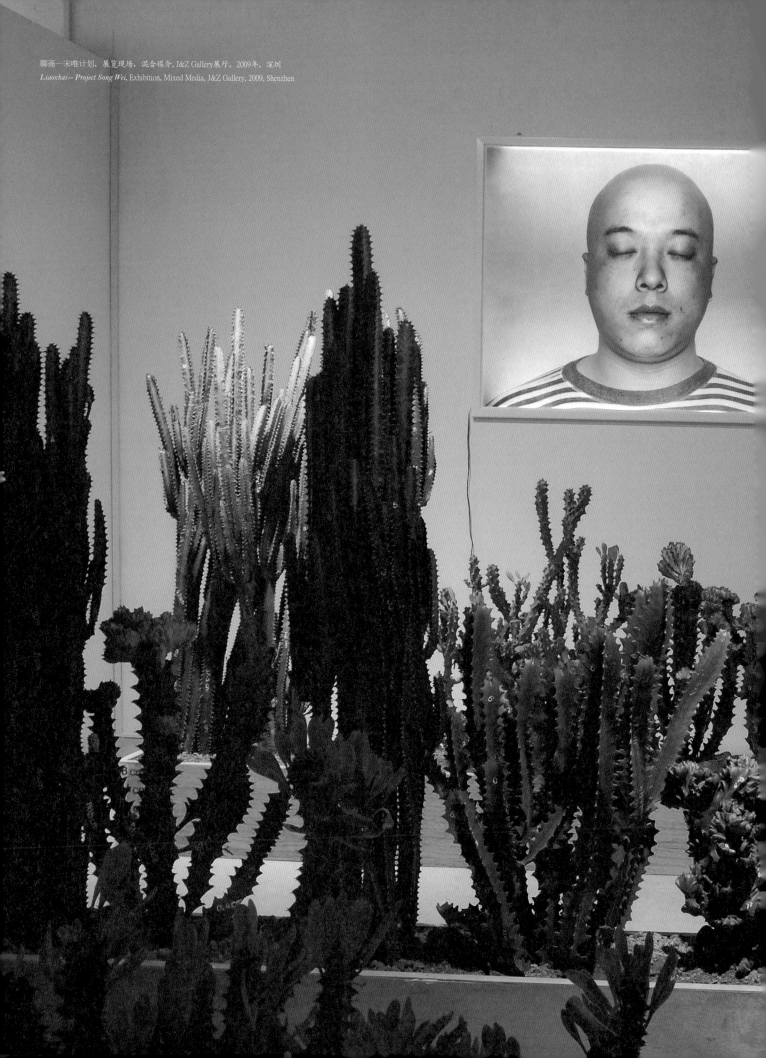

聊斋—宋唯计划，展览现场，混合媒介，J&Z Gallery展厅，2009年，深圳
Liaozhai-- Project Song Wei, Exhibition, Mixed Media, J&Z Gallery, 2009, Shenzhen

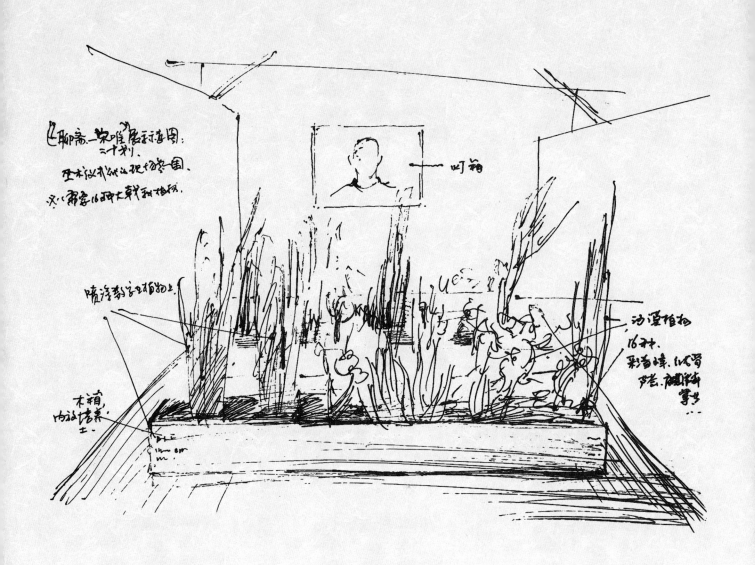

聊斋—宋唯计划，为个展准备的展览方案，2009年
Liaozhai-- Project Song Wei, Exhibition Plan Text for solo Exhibition, 2009

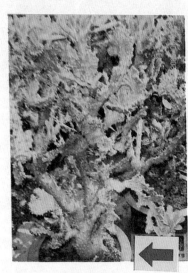

Eephorbia
neriifolia var.
cristata.
麒麟掌.

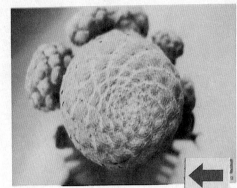

鱼鳞大戟.
Euphorbia
piscider
mis

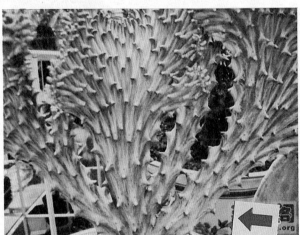

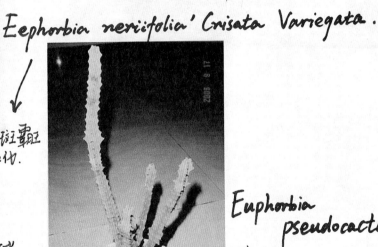

Eephorbia neriifolia' Crisata Variegata.

斑叶玉麒麟锦缀化. 别名:黄斑霸王
鞭缀化.

Euphorbia
pseudocactus
春驹

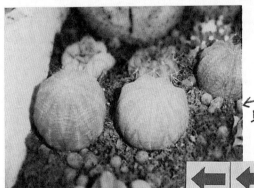

←布纹球.
别名:晃玉.
麒麟玉.
八卦球.
贵宝玉
圆大戟.

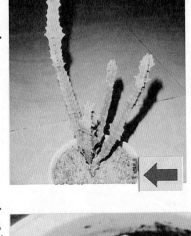

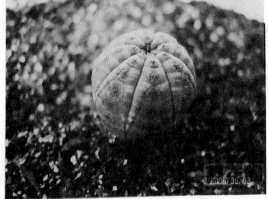

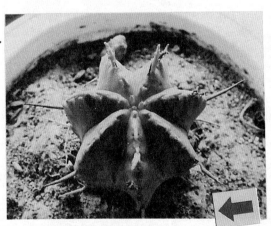

世蟹丸

Euphorbia pulvinata.

为"聊斋一来里印刷"收集的大戟种植物资料,2008年
The Information about Euphorbiaceae vegetation collected for Liaozhai--- Project Song Wei, 2008

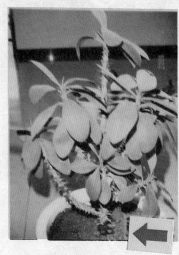

Euphorbia mili

虎刺梅．别名：铁海棠．麒麟花．麒麟刺．托麒麟．番刺仔．万年刺．老虎等．虎刺．金刚纂．叶仙人掌．

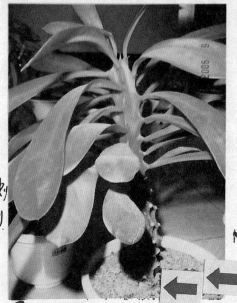

Euphorbia neriifolia

霸王鞭．

麒麟勒．

Euphorbia mili f. cristata.

虎刺梅缀化．

布纹球
别名：晃玉．八卦球．贵宝玉．圆大戟．

Euphorbia obesa

Eephorbia neriifolia var. cristata.

134

姬麒麟.旌节.

绮丽角.

蜈蚣.方连麟其.旌节.

红剑.红阁.
别名:红龙骨.

←一麒麟旌节冠.
别名:麒麟旌节冠.

龙骨冠.
大角大战.
隔田之雪.

为"聊斋—宋唯计划"收集的大戟科植物资料,2008年
The Information about Euphorbiaceae vegetation collected for Liaozhai--- Project Song Wei, 2008

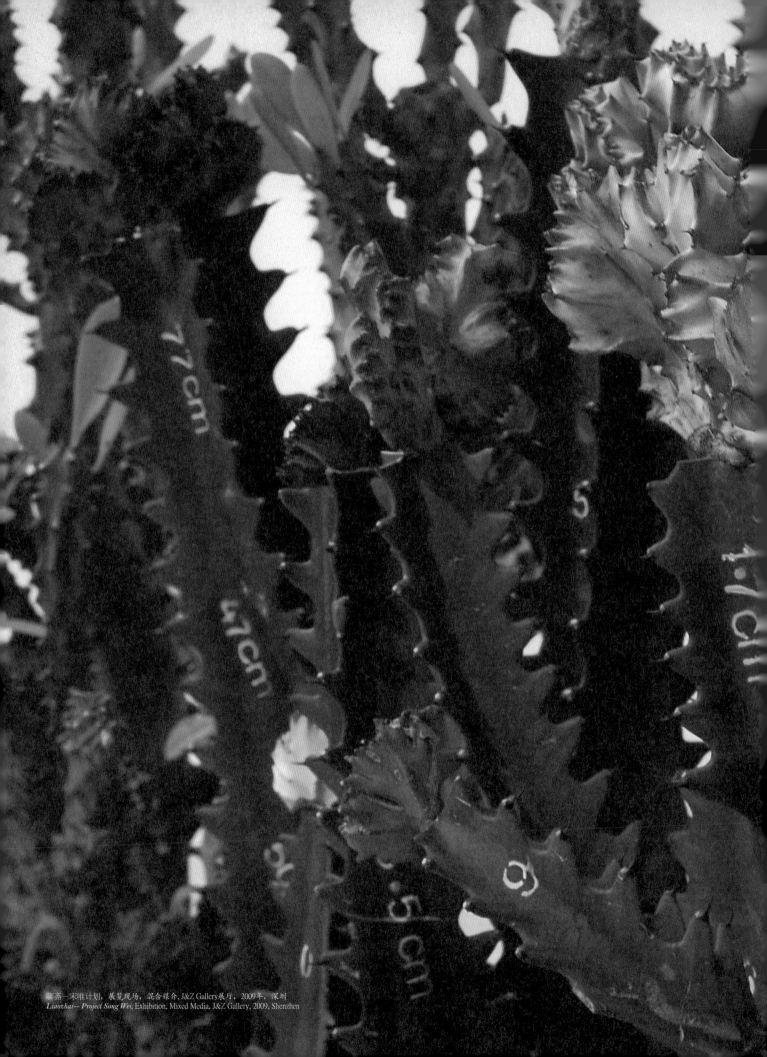

聊斋—宋唯计划，展览现场，混合媒介，J&Z Gallery展厅，2009年，深圳
Liaozhai-- Project Song Wei, Exhibition, Mixed Media, J&Z Gallery, 2009, Shenzhen

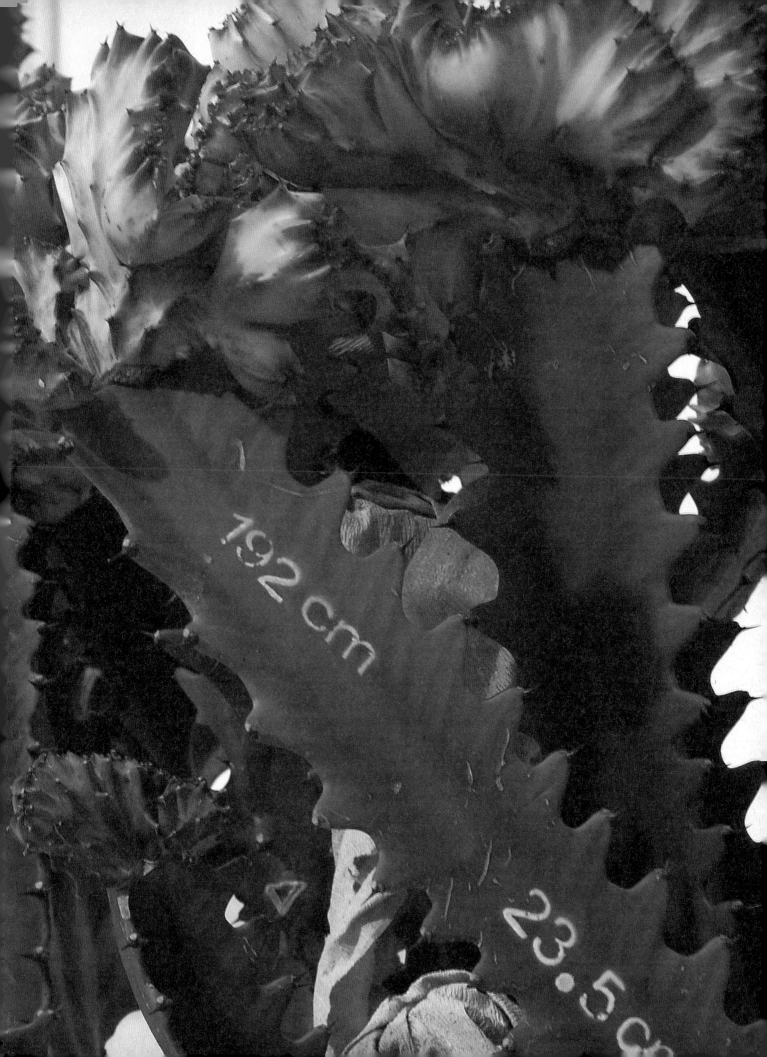

大戟阁锦
Euphorbia ummak
f. variegata.

别名：雪雪
孔雀姬.
孔雀丸
伏南大戟
Euphorbia flanaganii

密刺麒麟花科
Euphorbia baioe
-nsis

峦岳麒麟
Euphorbia abyssinica

铜绿麒麟
Euphorbia aeruginosa

斑纳麒麟科
Euphorbia barnard
-ii

铜绿麒麟科

日出
Euphorbia biaceae'
Sunrise

红麒麟科 Euphorbia aggregata.

Euphorbia Zoutpans
bergensis
鬼角麒麟科.
别名: 绿色通道.

Monadenium
ritchiei ssp.
nyambense.

将军阁.
别名: 甦翡
翠塔.

Monadenium
gventheri.
紫纹龙

Euphorbia decaryi
琉璃晃 v. spirosti
cha.
别名: 留璃晃
琉璃光.
硫璃晃

Monadenium gventheri
紫纹龙.

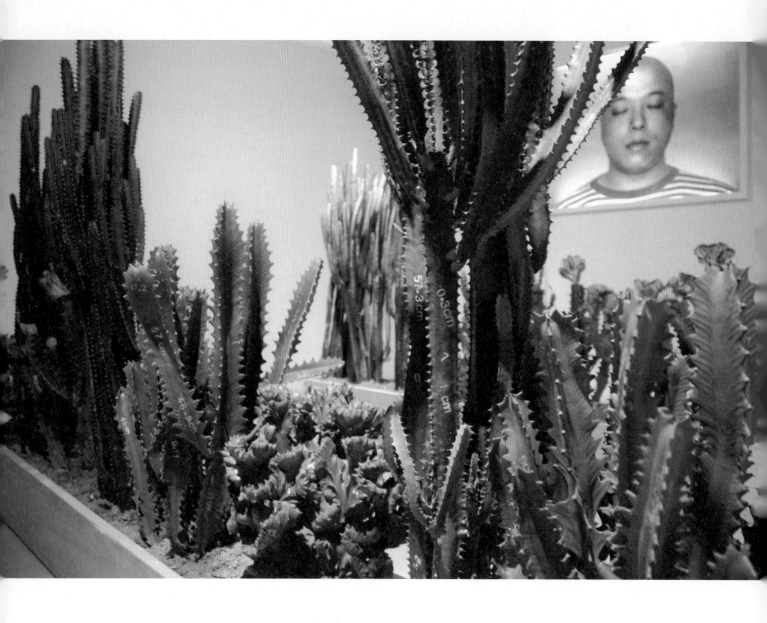

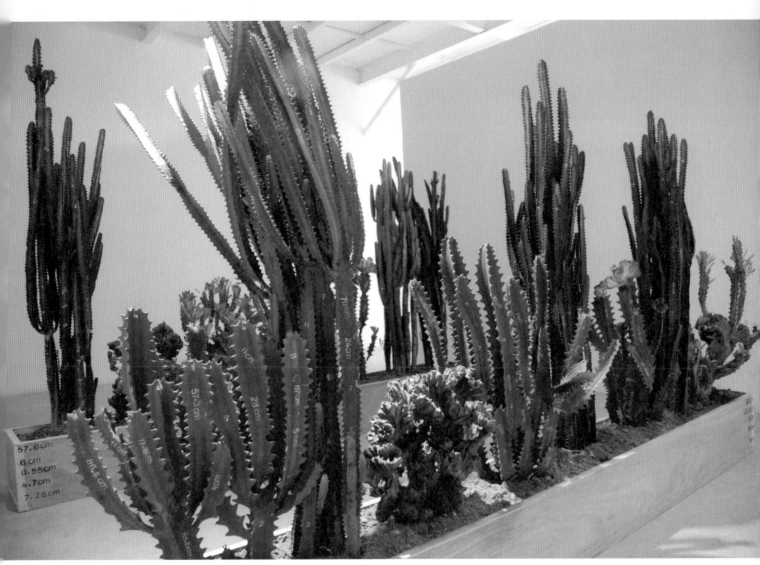

聊斋—宋唯计划，展览现场，混合媒介，J&Z Gallery展厅，2009年，深圳
Liaozhai--Project Song Wei, Exhibition, Mixed Media, J&Z Gallery, 2009, Shenzhen

青峰之辉

青峰之辉

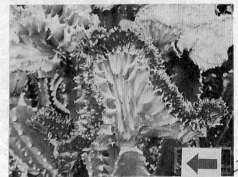

青峰之辉.

Euphorbia † lactea f. cristata
Albavariegate.

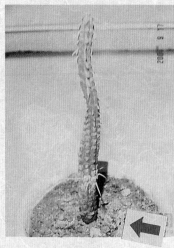

Euphorbia mammillaris
玉鳞凤.
别名: 鳞宝. 优龙球宝
龟甲麒麟龙骨.

Euphorbia mammillaris 'Variegata.*
白桦麒麟龙骨.
别名: 玉麒麟凤锦.

Euphorbia meloformis
贵青玉. 别名: 玉司.
林檎麒麟龙.

虎刺梅缀化

Euphorbia mili † cristata.

九头龙

Euphorbia inermis

狗努子

Euphorbia knuthii

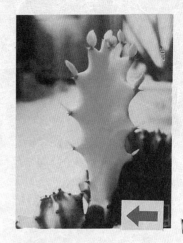

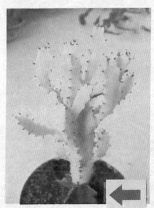

帝锦，别名：
乳白色麦大戟．

*Eephorbia lacter Haw.
, white Ghost'.*

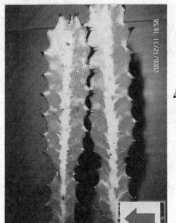

衡早阁．别名：里几翡翠
塔．

为"聊斋—宋唯计划"收集的大戟科植物资料，2008年
The Information about Euphorbiaceae vegetation collected for Liaozhai--- Project Song Wei, 2008

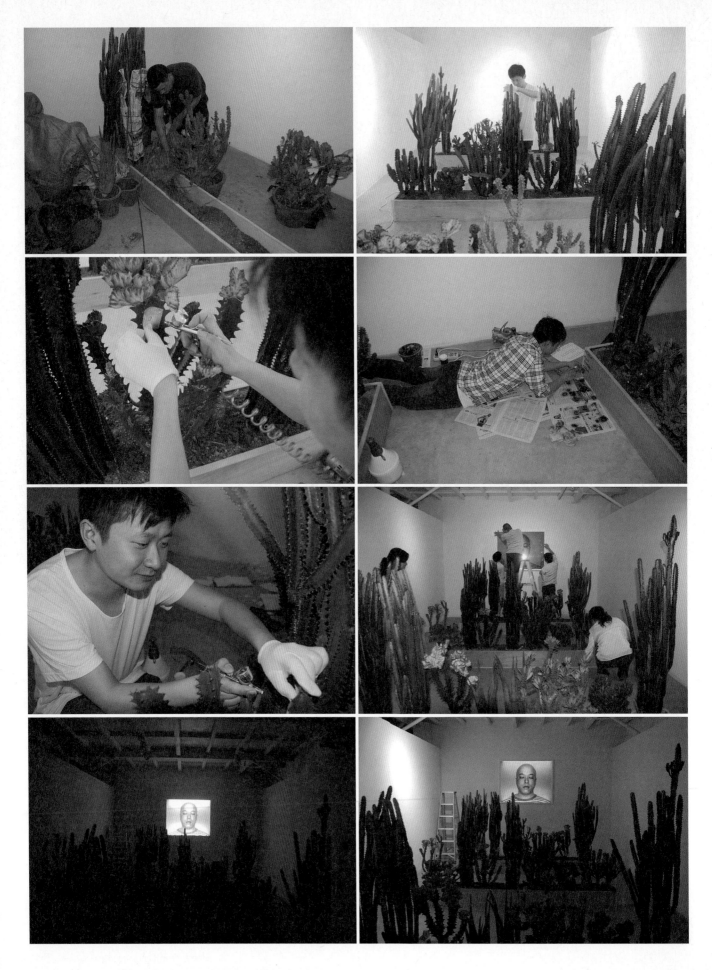

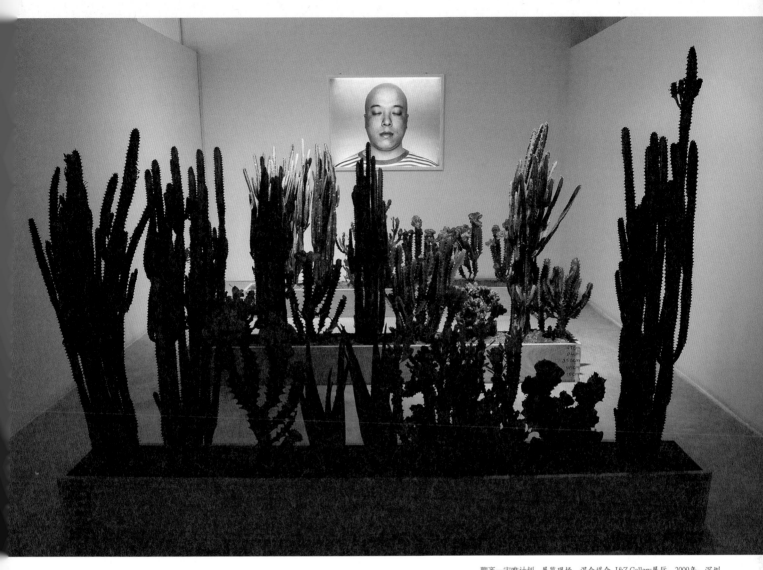

聊斋—宋唯计划，展览现场，混合媒介, J&Z Gallery展厅，2009年，深圳
Liaozhai--Project Song Wei, Exhibition, Mixed Media, J&Z Gallery, 2009, Shenzhen

聊斋—宋唯计划，工作记录，混合媒介，深圳J&Z Gallery展厅，2009年3月
Liaozhai--Project Song Wei, record step, Mixed Media, J&Z Gallery, Shenzhen, Mar 2009

数字的话语权：

············ 由测量"身体数据"而引发的思考

魏言

通过测量让我们去相信些什么，不相信什么？

今天的宇宙观念简单成了三维效果图——由计算机处理各种各样测量数据渲染出来的图纸。从阿基米德开始，人类测度的范围就已经不仅限于地球了。测度已经是我们生活当中的一部分。一切生活的主题都是建立在个人资源占有情况的测量之上被构想和安排的。有计划和控制的生活离不开细致的计算和测量，尤其在一个经济社会里，人们甚至开始用测量这种理性的手段施加到人类复杂的情感方面。比如人与人的关系可以通过计算交往次数和程度等统计学模块来测算出信任度和信贷数值。理性的测度泛滥于各类广告特别在食品安全检测数据当中。在一个全面靠测量来制定各种数据指标进行控制和管理的新型社会到来之时，对测度这一人类理性行为需要进行重新认知。

我们测度到的自己或他人的物理形态并不是出自实际用途的需要，只为了证明某物的"存在"的真理性，我试图唯心地使某物的存在依赖于测量而证明其存在与否。我需要以一种偏执的测量行为来使自己"相信"某物的存在，俨然是一种心理安抚，同时也暴露出我们对身外之物存在着信心不足。这是测度行为本身包含着的复杂的道德意义：测度是一种对无庸置疑的存在的挑衅和无视。如果人们坚信某些崇高之物是自在永在的，是绝对真理性存在，那么如果有人对其进行测度，那他就是在亵渎真理.在西方中世纪的"反圣像运动"就是按此道德逻辑而生成的集体性疯狂，逻各斯语音中心主义成就了现实当中的文化禁忌。

测度一件我们要去相信的"事实"究竟意味着什么？就像一个基督教徒要去通过测量数据来证明上帝存在这一行动可能潜伏着的信仰危机，因为，测量的结果有可能证明了另一个截然相反的结

无题, 纸本水彩, 40×50厘米, 2004年
No Title, Watercolor on Paper, 40×50cm, 2004

无题, 纸本水彩, 40×50厘米, 2004年
No Title, Watercolor on Paper, 40×50cm, 2004

论。哥白尼、伽利略在那个年代给宗教信仰带来的灾难犹如世界末日一般,而他们的确以测度和记录改变了人们的信仰,也改变了现代社会,人们按照他们的轨迹而制造出了电脑芯片、电视显像管、各种各样的晶体管、电路板和仪器,这些改变了我们生活乃至生存的东西.人类开始坚信除了自身以外,没有更高级的存在形式了,因为我们所能接触到的世界早已被测量过了,而这个由测量数据构成的世界里,没有"神"的存在空间。

然而,现代知识体系所创造的同样是一个"神话",一种以数学、物理和现代信息技术所缔造的一个"神话"。今天,Google Earth所展现在世人面前的正是这样的神话般的世界,只是上帝的视线俨然已由通讯卫星代替了。随着大量信息技术和新型媒体不断刷新我们头脑里的观念和经验,这个新神话世界正在崛起,正在瞬间改变着人类的生活方式。在不太遥远的未来,它将产生新型的统治工艺学。然而,危机却始终会是人类的宿命。也许真像

电影里所虚构的那样,在数据的某个角落,某个模糊数学领域内的盲点,例如一小片阴影所构成的缝隙里,包含着另外一种需要被开启的心智。就如同《黑客帝国》所描述的,我们生活在一个巨大的阴谋里面,我们会相信测量带来的谎言并认为那是唯一。这一切是眼下正在发生的……卡夫卡仍旧以忧郁的眼神注视着那个地质测量员的一举一动……

结论:测量,任何时候都是一种需要小心谨慎的行为,因为你有可能发现/遗漏;相信/不相信;接受/拒绝,事实的真相。

The Discourse Power of Number:
·········· the Thinking Caused by Measuring "Physical Data"

Wei Yan

无题, 纸本水彩, 40×50厘米, 2004年
No Title, Watercolor on Paper, 40×50cm, 2004

Today the concept of universe can be represented directly by 3D graphics – created by computer according to the data collection from measurement. Speculation and hypothesis are no longer required. Since Archimedes, human measures beyond the earth. Measurement became part of our life even before the time of industry. Life is now no more than a process where all social resources available for an individual are measured, calculated, planned and distributed. Life of plan and control requires detailed calculation and measurement. In the modern society where "global economic integration" happens, people even begin to adopt this rational tactic of measurement to emotions. For example the evolvement of "credit" in forms of data: this human relationship becomes numerical with degree of trust and limit of credit, based on a database of times and quality of connection. Rational measurement overflows in all kind of advertisement, even in the examinations of food security. In a new society that depends totally on measurement to control and manage, measurement itself as a rational human behavior should be reviewed: by measuring the measurement.

We don't measure physical data of the others or ourselves for practical reason, but for proving the authenticity of "existence". I try to determine if something exists or not by measuring. I need monomaniacal actions of measurement to "persuade" myself of the existence of a thing. Psychological conciliation is apparently involved. In the mean time, my suspicion on all the others which are other than ourselves has been exposed. The practice of measurement includes complicated moral issues on itself: to measure the legalized "existence" means defiance to it. When something sublime is so believed to be natural, eternal and the absolute truth, that no one dare doubt of it, it will be blasphemous to measure it. In this logic, Iconoclasm in the middle ages can be a massive madness. And Phonocentrism created the culture taboo of human society.

What does it mean to measure a so believed "truth"? Belief faces crisis when a Christian tries to approve the existence of God by collecting data, because a negative result will be accepted if given by the measurement.

Copernicus and Galileo brought almost the end of world for religion at that time, as they have changed people's belief by measuring and recording, and introduced the modern society. Chips, kinescope, transistor, various electronical devices have been created through the development of science, changing our life and the world. Man begins to regard himself as the highest level of existence. After measuring the whole world within his range, man finds no space for "gods" in this world of data.

Nevertheless, what the modern knowledge system has created is still a "myth", built by mathematics, physics and IT. Google earth can already present a world of myth as the version of god has been replaced by satellite. While mass information from technology and media keeps refreshing our mind, the myth is rising and changing human life. In the near future, it will bring a new technical of control but human life will always be accompanied by crisis. In some fictive worlds in the movies, a blind point, according to fuzzy mathematics, is hiding in a corner of infinite data, like another kind of mind to be opened in the aperture of shadows. In the movie "Matrix", human is living in a plot which has been surveyed and then believed to be the only truth. This is also happening in our world. Kafka is watching with melancholy the surveyor's action···

Conclusion: to measure is an action that needs continuous prudence because we can discover/miss; believe/disbelieve; accept/refuse the truth through it.

(This article was first published in January 18, 2009 on personal blog homepage http://blog.artintern.net/weiyan)

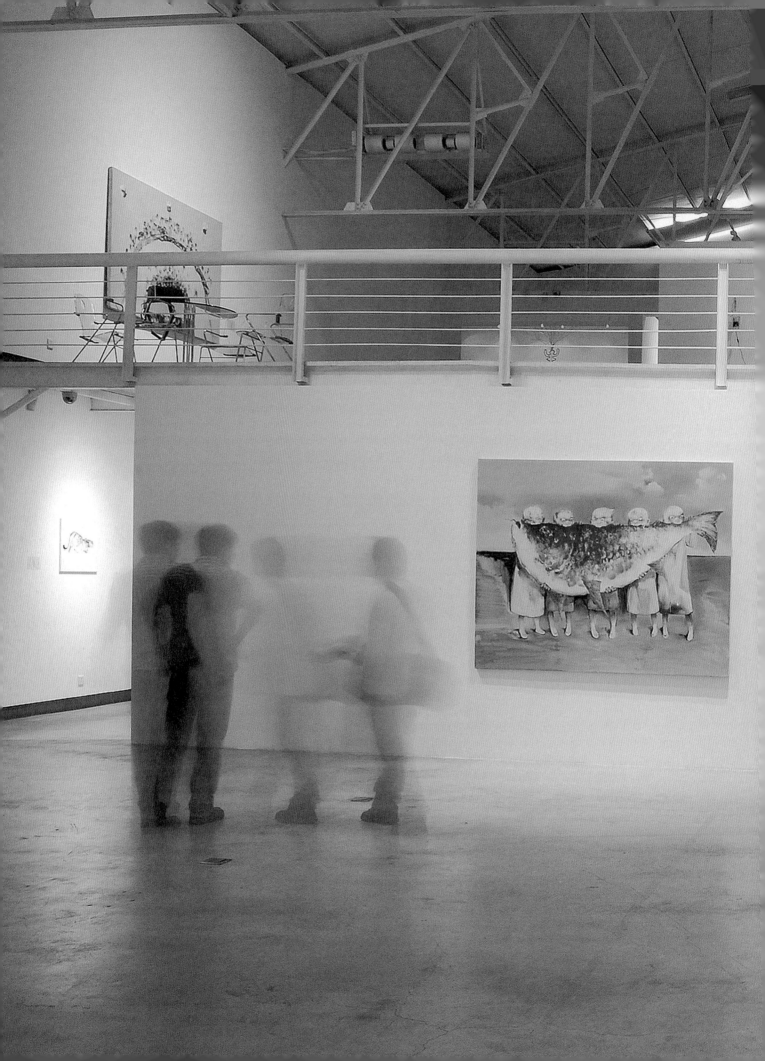

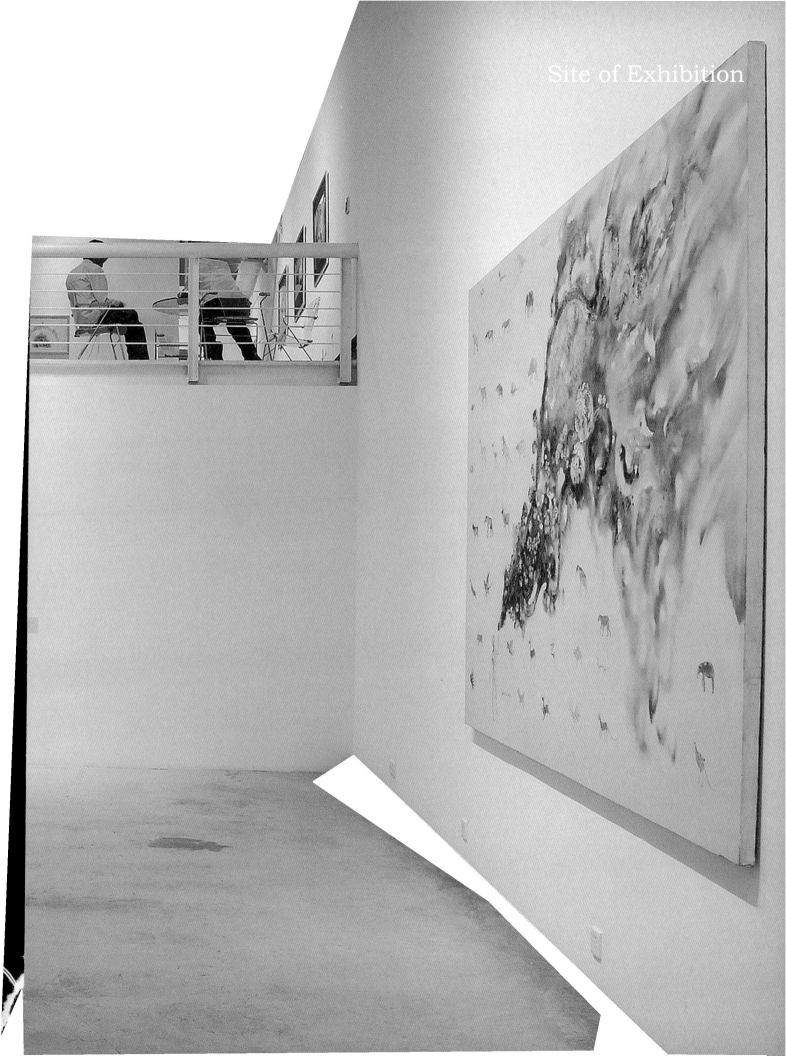

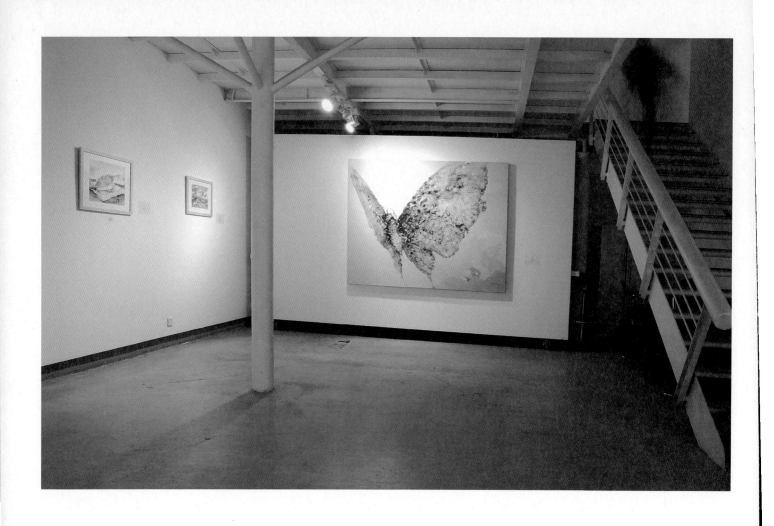

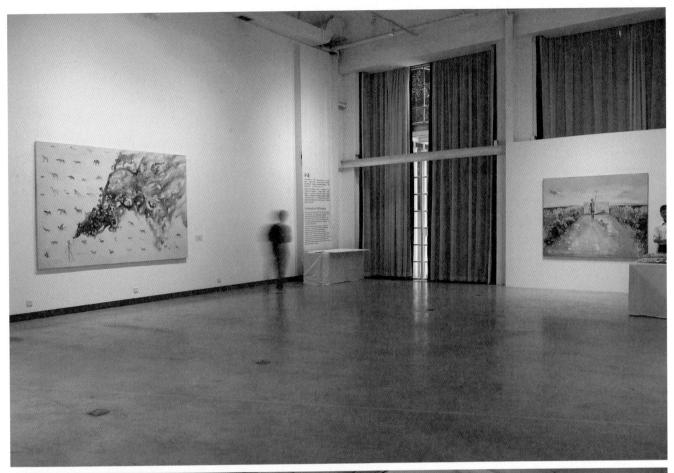

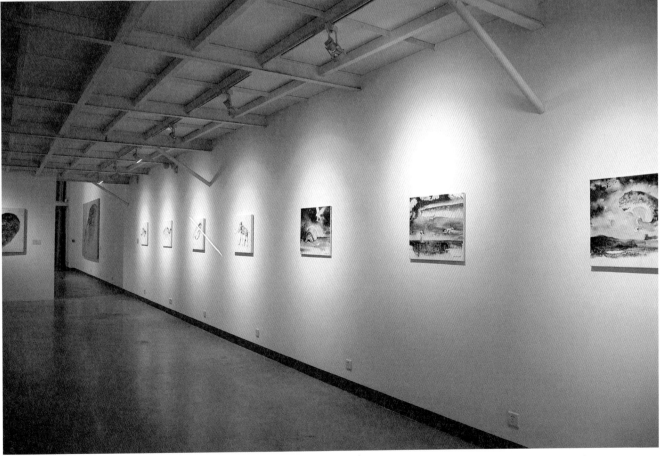

Biography

1975年生于中国四川省自贡市，
1996年毕业于四川美术学院附中，
2000年毕业于四川美术学院油画系，获学士学位，
2007年川音成都美术学院油画系研究生毕业，获硕士学位，
现任教于川音成都美术学院油画系，讲师。

1975 Born in Zigong city, Sichuan Province, China.
Currently lives and works in Chengdu city.
1996 Gradated from the Attached High School of
Sichuan Arts Institute.
2000 Graduated from the Department of Oil painting,
Sichuan Fine Arts Institute.
Now teaching in Chendu Fine Arts
Institute,lecturer,M.A.

个展

2009年
"异述—Alternative Reference" J&Z 画廊，华侨城 LOFT，深圳

展览

2009年
多棱镜，麓山国际A4画廊，成都
未来索引：自然.不自然，尚堡美术馆，宋庄，北京
群落！群落！，宋庄美术馆，宋庄，北京
重庆青年美术双年展，重庆国际会展中心，重庆
废话-2009成都当代艺术年展，天艺村美术馆，成都
个性：北京之外的新艺术，红门画廊，北京
A+A' 2009—A+A第四回展，偏锋新艺术空间，北京
归去来兮，重庆美术馆，重庆
进化-evolution，多伦现代美术馆，上海
双城记，廊桥艺术空间，成都

2008年
震·撼——自然的力量，蓝色空间，成都
欲象 II，本色美术馆，苏州
自然的消逝，J&Z 画廊，深圳
SOLO ART，北村独立工场，成都
亚洲国际当代艺术展，亚洲国际博览馆，香港
A+A' 2008—A+A第三回展，偏锋新艺术空间，北京
Quietness，艺术+上海画廊，上海
意大利博洛尼亚艺术博览会，博洛尼亚展览中心，意大利

2007年
截点--当代艺术的中国形象，三峡博物馆，重庆
2007上海艺术博览会青年艺术家推介展（亚洲），世贸中心，上海
刮痧，齐盛艺术馆，成都
欲象 I，宋庄美术馆，北京
透明之局—"虫在昆仑"十年行为作品实施，昆仑山，可可西里
1976-2006乡土现代性到都市乌托邦——"四川画派"学术回顾展
　　中国文化部对外交流中心，北京
A+A' 2007—A+A第二回展，中央美术学院美术馆\重庆美术馆\北京798
第三届贵阳双年展，贵阳美术馆，贵阳
新动力·中国艺术家提名展，上海美术馆，上海

2006年
新动力·中国，原弓美术馆，上海
出格，偏锋新艺术空间，北京
Beijing，今日美术馆，北京

2005年
后人类报告，蓝色空间画廊，成都

2004年
新经验图像，上海国际展览中心，上海

2003年
四川省第二届青年油画展览，四川美术展览馆，成都
中国第三届油画展，中国美术馆，北京

2002年
蘑菇云，或者是乌托邦？外滩美术馆，上海

1999年
第九届全国美展-重庆地区展，重庆美术馆，重庆

1998年
入选"98' 国际美术年-中国当代山水画、油画风景展"，中国美术馆，北京

1996年
望江茶楼，四川美术学院，重庆

活动策划

2008年策划"北村独立工场"，成都
2004年策划"以元素介入"实验绘画作品展览，成都

Selected Solo Exhibition:

2009
Alternative Reference，J&Z Gallery，OCT LOFT，ShenZhen

Selected Group Exhibitions:

2009
Prism, A4 Gallery, Chengdu
Community！Community！Song Zhuang Gallery, Beijing
Chongqing Youth's Biennial, International Exhibition Center, Chongqing
Crap - 2009 Chengdu Contemporary Art Annual Exhibition TianYi Gallery, Chengdu
Individuality: new art from beyond Beijing, Red Gate Gallery, Beijing
A+A' 2009 A+A -- 4th Exhibition, PIFO NEW ART studio, Beijing
Homeward Bound, Chongqing Art Gallery, Chongqing
Evolution, DOLAND Art Museum, Shanghai
Tale of Two Cities, Re-C Art Space, Chengdu

2008
Shake . Shock － Power of Nature, Blue Space Gallery, Chengdu
Images of Desire II , BenSe Art museum, Suzhou
The Disappearance of Nature, J&Z Gallery, Shenzhen
SOLO ART, North Village Independent Workshop, Chengdu
Asia's International Contemporary Art Exhibition, Asia World Expo, HongKong
A+A' 2008—A+A 3rd Exhibition, PIFO NEW ART studio, Beijing
Quietness, Art+ Shanghai Gallery, Shanghai
Italy Bologna Art Fair, ologna Exhibition Center, Italy

2007
Interception Point - China's Image In Contemporary Art , SanXia Museum, Chongqing
2007 Recommendation Exhibition for Young Artists in Shanghai Art Fair (Asia)
 World Trade Center, Shanghai
Scrapping, QiSheng Gallery, Chengdu
Images of Desire I , SongZhuang Gallery, Beijing
Transparent Situation — "Spiritual Creature in Kunlun Mountain"
 - the beginning of a Perform in 10 years KunLun Mountain, Kekexili
1976-2006 from predial Modernism to Urbanism Utopia -- "Sichuan School"
 Academic Review Exhibition Foreign Exchange Center, Beijing
A+A' 2007—A+A 2nd Exhibition Gallery of Central Academy of Fine Art
 / Chongqing Art Gallery/ Beijing798
Third Guiyang Biennial, Guiyang Art Gallery, Guiyang
New Power・China Nominative Exhibition, Shanghai Art Gallery, Shanghai

2006
New Power・China, YuanGong Gallery, Shanghai
Transgression, PIFO NEW ART studio, Beijing
Beijing, Today Art Gallery, Beijing

2005
Post Human Report, Blue Space Gallery, Chengdu

2004
Experience Image, Shanghai International Exhibition Center, Shanghai

2003
Second Sichuan Young Artists Exhibition of Oil Painting,
 Sichuan Art Gallery, Chengdu
Third China National Exhibition of Oil Painting Chinese Art Gallery, Beijing

2002
Mushroom Cloud or Utopia, The Bund Gallery, Shanghai

1999
Ninth China National Exhibition of Art - Sichuan area,
 Chongqing Art Gallery, Chongqing

1998
98' International ART Year - The Contemporary Landscape Painting In China,
 Chinese Art Gallery, Beijing

1996
WangJiang Tea House (Independent Workshop),
 Sichuan Fine Arts Institute, Chongqing

Planned Activities

2008
The "North Village Independent Workshop", Chengdu

2004
"Intervention with Element" -- experimental paintings Exhibition, Chengdu

异述：魏言个展
Alternative Reference : Wei Yan Solo Exhibition

展期/Date：2009/3/28-2009/5/28
深圳OCT-LOFT艺术方位J&Z Gallery

J&Z Gallery

深圳市华侨城恩平路设LOFT_F1栋101　邮编:518053
101 Bldg F1,OCT-Loft,Enping Rd.,Shenzhen 518053
tel:+86 0755 86102503
fax:+86 0755 86102504
yishufangwei@163.com
www.jzgallery.com